# Collection Applied Design:
# A Kim MacConnel Retrospective

MUSEUM OF CONTEMPORARY ART SAN DIEGO

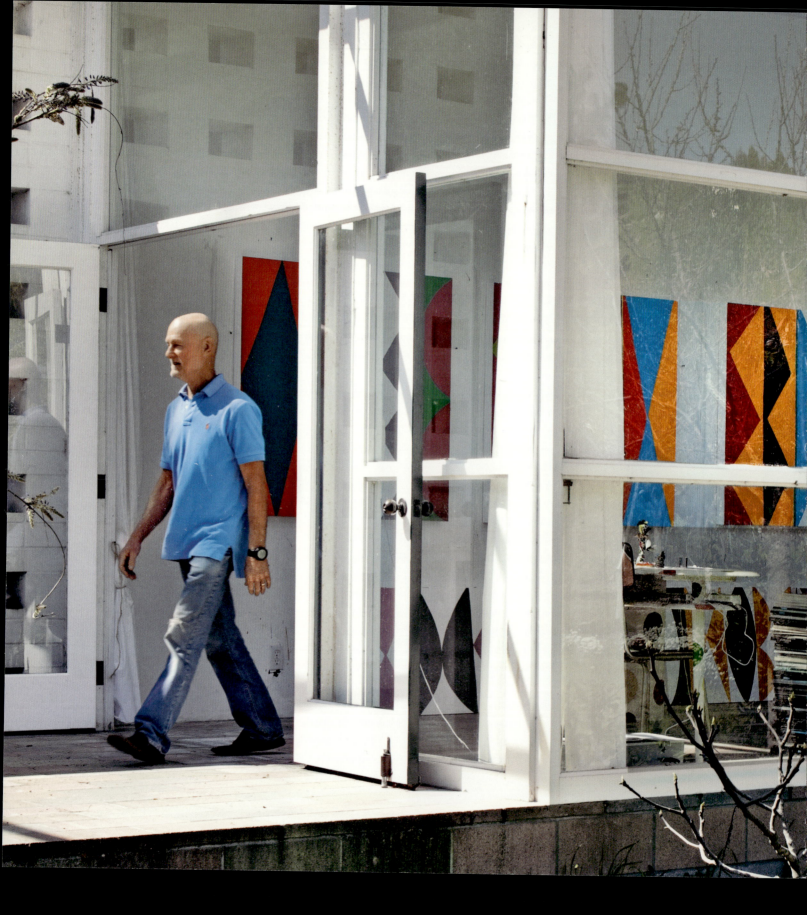

Published on the occasion of the exhibition *Collection Applied Design: A Kim MacConnel Retrospective*, on view in La Jolla, California, from October 9, 2010 through January 23, 2011.

*Collection Applied Design: A Kim MacConnel Retrospective* is organized by the Museum of Contemporary Art San Diego and is made possible with the support of San Diego County Board of Supervisors Chairwoman Pam Slater-Price and the County of San Diego Neighborhood Reinvestment Fund. Additional support for the exhibition is provided by Renée Comeau and Terry Gulden.

Related programs are supported by grants from The James Irvine Foundation Arts Innovation Fund, the County of San Diego Community Enhancement Fund, and the Institute of Museum and Library Services.

Institutional support for MCASD is provided, in part, by the City of San Diego Commission for Arts and Culture.

© 2010 Museum of Contemporary Art San Diego. All rights reserved. No part of the contents of this book may be published without the written permission of the Museum of Contemporary Art San Diego, 700 Prospect Street, La Jolla, California, 92037-4291, 858-454-3541, www.mcasd.org. The copyrights of the works of art reproduced in this book are retained by the artists, their heirs, successors, and assigns.

ISBN: 978-0-934418-72-0
Library of Congress Control Number: 2010937359

Available through D.A.P./Distributed Art Publishers
155 Sixth Avenue, 2nd Floor
New York, New York 10013
Telephone: 212-627-1999; Fax: 212-627-9484; www.artbook.com

Curator: Robin Clark
Editor: Sherri Schottlaender
Design: Ursula Rothfuss

Printing coordinated by Uwe Kraus, Vancouver, Canada
Printed in Germany

Front cover: Kim MacConnel, *E123* (detail), 2010.
Enamel on wood, triptych: 46 x 46 inches each.
Museum of Contemporary Art San Diego, Museum purchase,
International and Contemporary Collectors Funds

Frontispiece: Kim MacConnel at his studio, 2010

Page 7: Kim MacConnel's studio, 2010

Back cover: Kim MacConnel, *Horsey Set* (detail), 1985.
Painted fabric, 94 x 108¾ inches. Museum of Contemporary Art
San Diego, Gift of Laurie and Brent Woods

**Contents**

6 FOREWORD
Hugh M. Davies

8 ACKNOWLEDGEMENTS
Hugh M. Davies and Robin Clark

9 LENDERS

11 A CONVERSATION
WITH KIM MACCONNEL
Robin Clark

27 MACCONNEL MODERN:
A COLLECTION OF APPLIED DESIGNS
Richard D. Marshall

39 WORKS BY KIM MACCONNEL

72 INSTALLATION VIEWS

82 MURALS

86 EXHIBITION CHECKLIST

89 SELECTED EXHIBITION HISTORY
AND BIBLIOGRAPHY

# Foreword

It is a tremendous pleasure for the Museum of Contemporary Art San Diego to present *Collection Applied Design: A Kim MacConnel Retrospective*. This exhibition surveys four decades of work by a painter and object maker who has dynamically and confidently engaged questions of abstraction, figuration, and decoration throughout his career. Kim MacConnel draws inspiration from a range of sources, including found graphic images, patterned fabrics, and the detritus that washes up on beaches. His exuberant work is informed by various experiences of travel, including a self-conscious examination of the role of the tourist.

While this exhibition is certainly a retrospective of MacConnel's work, it goes beyond a chronological examination of his artistic development, instead evoking experiences of key exhibitions staged in the course of the artist's career. *Collection Applied Design* was designed specifically for MCASD's La Jolla location, and it takes into account the domestic scale of some of the galleries, the dialogue with the coastal landscape outside, and the juxtapositions of scale that occur throughout the building. One portion of the exhibition focuses on MacConnel's fabric pieces from the 1970s, beginning with his early interest in remixing abstract forms based on Near Eastern textiles. Also featured in the show are the artist's installation of materials found while beach combing; photographic works; and painted furniture pieces. Just as MacConnel moves with confidence between media, he deftly tackles dramatic shifts in scale, from architectural installations and large-sized canvases to intimate watercolors and collages. Here at MCASD, the grouping of examples of all of these types of work has resulted in a lively exhibition that transforms the building into a MacConnel meta-installation.

MCASD—then called the La Jolla Museum of Contemporary Art—hosted Kim MacConnel's first major museum exhibition in 1976. He was already based in San Diego at that time, but his work was being presented across the country; I recall seeing his fabric pieces and painted furniture in New York in the 1970s at Holly Solomon's gallery and at other museums. The fact that San Diego was home to artists of MacConnel's caliber was one of the reasons I was attracted to this city, and during my tenure at MCASD it has been such a pleasure to show his extraordinary work on many occasions at both our La Jolla and downtown locations.

In my estimation, some of the strongest work in his career is also his most recent. His brilliantly colored enamel abstractions, painted earlier this year, are a perspicuous summation of his artistic concerns. I do not lightly refer to the work of Henri Matisse, but MacConnel's compositional exuberance and clarity of color in this newest work reflect a confidence and ease only earned by a rare few. We are proud to have collaborated with the artist to realize this important exhibition and publication.

Dr. Hugh M. Davies
The David C. Copley Director and CEO

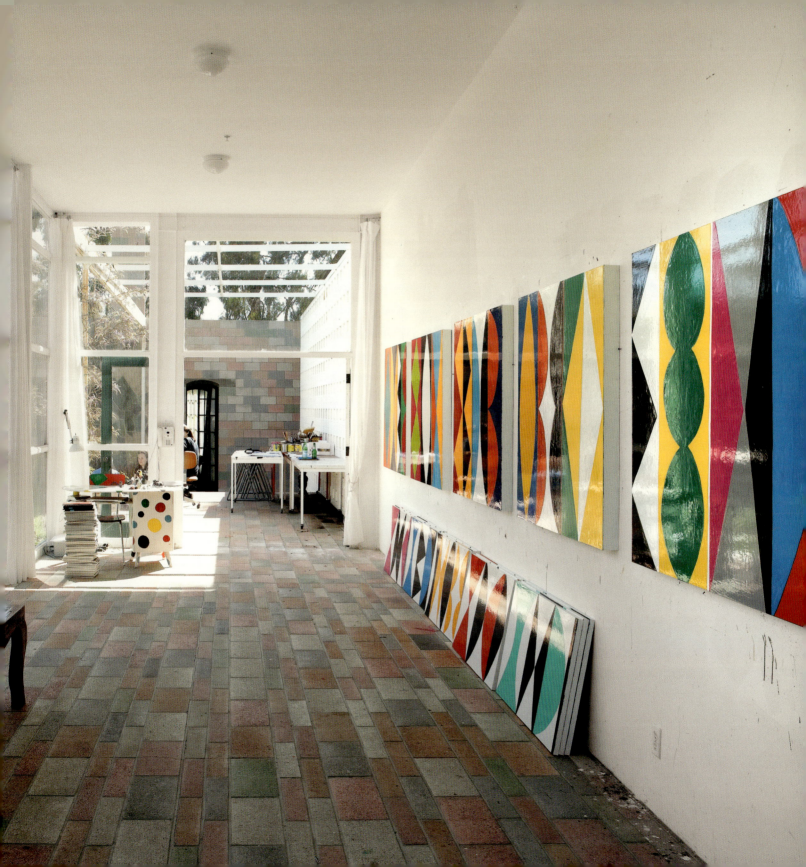

## Acknowledgements

We would like to offer our heartfelt gratitude to everyone who has contributed to the realization of this exuberant exhibition and catalogue. Above all, we thank Kim MacConnel, who has been a full partner in this project, demonstrating enormous generosity in terms of both his time and his work.

*Collection Applied Design: A Kim MacConnel Retrospective* would not have been possible without the generosity of public and private lenders who have graciously parted with cherished works during the course of the exhibition, and we thank them: Marcia Acita, Assistant Director of the Marieluise Hessel Collection, Hessel Museum of Art, Center for Curatorial Studies, Bard College, Annandale-on-Hudson, New York; Bruno Bischofberger, Zurich; Renée Comeau and Terry Gulden; David Diamond and Karen Zukowski; Sue K. and Charles C. Edwards; Rosamund Felsen; Susanna and Michael Flaster; Ellen and Jimmy Isenson; Roy and Gail Kardon; Leon and Sofia Kassel; Nina MacConnel and Tom Chino; Elvi Olesen and Richard Singer; Dr. and Mrs. J. Harley Quint; Charles Reilly and Mary Beebe; Glenn Schaeffer; Marcia and Irwin Schloss; Rob Sidner, Director of the Mingei International Museum; John and Thomas Solomon; Julie Reyes Taubman and Bobby Taubman; Erika and Fred Torri; and two anonymous collectors. We are tremendously grateful for the assistance of Mark Quint, Ben Strauss-Malcolm, and Sarah Trujillo of Quint Contemporary Art in La Jolla and to Rosamund Felsen of Rosamund Felsen Gallery in Santa Monica for their assistance in locating works for the exhibition.

Special thanks are due to guest author Richard Marshall, whose essay in this publication is a fresh, thoughtful appraisal of the artist's work and also a reflection of his long association with Kim MacConnel. Designer Ursula Rothfuss and Editor Sherri Schottlaender share credit for the elegance with which the images and text flow throughout the book. We would like to acknowledge Museum staff across departments for their invaluable assistance in the production of this exhibition and catalogue. Under the leadership of our new Chief Curator, Kathryn Kanjo, many members of the Curatorial Department contributed to the success of the project. In particular we wish to thank Chief Preparator Ame Parsley and Preparators Jeremy Woodall and Thomas Demello for skilled installation of the exhibition; former Registrar and Collection Manager Laura Graziano, Associate Registrar Therese James, and Registrarial Assistant Cameron Yahr for coordinating loans and travel of artworks; Curatorial Manager Jenna Siman for ably tracking the schedules, budgets, and image permissions; Education Curator Gabrielle Wyrick and Education Programs Coordinator Elizabeth Yang-Hellewell for developing vibrant public programs; and Curatorial Interns Christina Shih, Maggie Dethloff, Brooke Kellaway, and Karen Noble for their support of the project. The fund-raising efforts of Chief Advancement Officer Jeanna Yoo and Stewardship Manager Cynthia Tuomi were critical to the success of this exhibition. We are also grateful for the guidance and assistance provided by Deputy Director Charles Castle and his administrative staff. Senior Communications and Marketing Manager Rebecca Handelsman and Communications Associate Claire Caraska enthusiastically shared this project with regional, national, and international audiences.

No project of this scope would be possible without generous financial support, and the Museum is especially grateful to the County of San Diego Neighborhood Reinvestment Fund and Renée Comeau and Terry Gulden for their contributions to this exhibition.

Dr. Hugh M. Davies  
The David C. Copley Director and CEO

Dr. Robin Clark  
Curator

# Lenders

Anonymous
Bruno Bischofberger, Zurich
Renée Comeau and Terry Gulden
David Diamond and Karen Zukowski
Sue K. and Charles C. Edwards
Rosamund Felsen, Rosamund Felsen Gallery, Santa Monica
Susanna and Michael Flaster
Marieluise Hessel Collection, Hessel Museum of Art, Center for Curatorial Studies, Bard College, Annandale-on-Hudson, New York
Ellen and Jimmy Isenson
Roy and Gail Kardon
Leon and Sofia Kassel
Nina MacConnel and Tom Chino
Mingei International Museum
Elvi Olesen and Richard Singer
Dr. and Mrs. J. Harley Quint
Charles Reilly and Mary Beebe
Glenn Schaeffer
Marcia and Irwin Schloss
John and Thomas Solomon
Julie Reyes Taubman and Bobby Taubman
Erika and Fred Torri

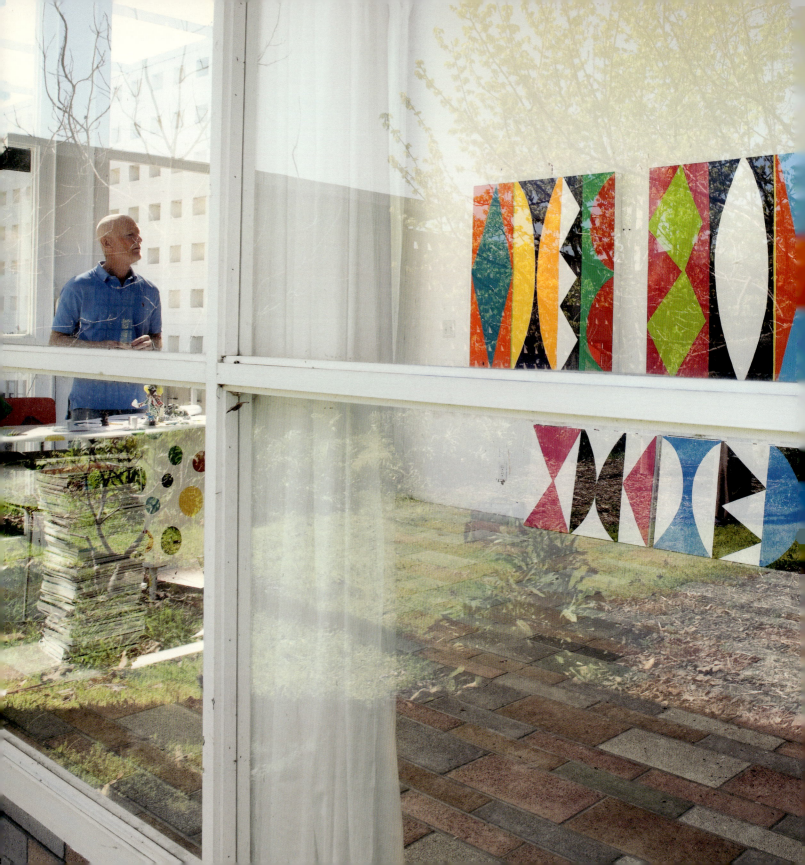

# A Conversation with Kim MacConnel

ROBIN CLARK

RC: You've mentioned that it was difficult to get your first show in a commercial gallery because your technique of sewing and painting on found fabrics was associated more with craft than modern painting. Who was the first dealer to respond to your work?

KM: Actually, the very first person was Jack Glenn, of Jack Glenn Gallery. You might not know of him because he was kind of an early Southern California contemporary art gallerist.

RC: Was he related to the curator Connie Glenn?

KM: Yes, right, they were married. He had this gallery in Corona Del Mar. I went up and dutifully showed him my work, and he said, "That's terrific! Can I keep this?" So he had a group show of people in the gallery, and he stuck my piece—it was *Turkish Copy* [1973]—in the window. He was—it was—actually really nice. It was kind of important, frankly—it gave me some confidence.

RC: And what happened next?

KM: There were a couple of little local shows, but it really wasn't until I met Holly Solomon that there was any kind of traction, and that took two or three years.

RC: How did you end up with your first solo exhibition in La Jolla [*Collection Applied Design: Kim MacConnel*, 1976]?

KM: Richard Armstrong was the curator. The space in the museum [then the La Jolla Museum of Contemporary Art] where the Farris Gallery is now used to be an art studio. That whole wing of the museum was used for teaching studios, and I guess the museum was thinking of turning them into gallery space. Richard liked my work and asked if I'd like to do something in that space, which had great big windows. I thought it would be a great idea to take the space and turn it into a salon—only three walls would have work on them and the middle of the room would have furniture for people to sit on and talk. And so I busily made work for that eventuality, and then we came in to install the work and the windows had been boarded up.

Opposite: Kim MacConnel at his studio, 2010

RC: Because …?

KM: To make it more like a gallery space. So I said OK, and I went home and made more pieces, including furniture, and brought them in. At the opening everyone sat around, and it was a real salon. But while the show was up one of the guards told me that there had been a shoving match between two patrons in the museum over whether one should sit on the art or not. So that was kind of interesting, and it spurred me on to make more.

RC: Was that the first time you showed painted furniture?

KM: Yes, I really made all of this work specifically for the museum. *Turquoise Settee*, in the Fayman Gallery, is one piece from the 1976 exhibition.

RC: And in 1975 you started showing with Holly Solomon. How long did you show with her?

KM: Until 2002, I think? I think that was when the gallery closed—well, when she died.

RC: Should we talk about that relationship? It seems to have been really important.

KM: Oh, it was huge. She was terrific. Initially, Horace, her husband, wasn't all that interested in my stuff, but he became interested to a good degree. But Holly was really, really engaged. And not just with my work, certainly: also Bob Kushner's and Valerie Jaudon's, and you know, she showed a very broad range of artists, from Gordon Matta-Clark to Richard Nonas, Gene Highstein, and Laurie Anderson. Just tons and tons of people. But Holly really was kind of interested in this little strange idea, and why she got interested in it, I don't know: it always surprised me, because in a way, what we were playing around with was kind of antithetical to her Pop interests, or her interest in the current scene, or her interest in her 98 Greene Street performance space in SoHo. Holly and Amy Goldin, who was my friend, were a little bit like oil and water—although they were pretty polite and nice to one another, they didn't really have shared interests, except for maybe Bob and me and Valerie Jaudon. Amy was the critic and art historian, so it was really interesting to me that Holly was the one who came up with the term "Pattern and Decoration" or "P&D." That skewed what we were actually doing, because what Amy, Bob, and I were particularly talking about was this hierarchy in terms of how people think about art versus craft versus extensions of non-Western things. So there was this kind of hierarchy of what's art and what isn't. And we were really interested in reevaluating

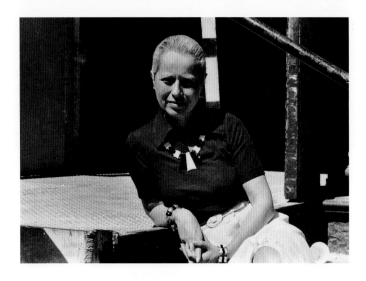

what that hierarchical order was and why it existed. In some ways it was kind of a scholarly interest, and the P&D moniker altered that somewhat.

RC: You considered it an art historical exploration?

KM: Right. I mean, Bob and Amy published a couple of things together, and Amy certainly was publishing stuff about Decoration, but in terms of me and Bob, to a great degree we were just interested in using it as a foundation for making work. It was enough to challenge the idea of a conceptualist-minimalist canon at the time. And that canon—minimal conceptualism or conceptual minimalism—was drifting more and more towards being minimalist and formulaic and less and less about the early playful conceptualist engagement seen in, say, 1968. The minimalist-formalist thing was taking over again, and I was just personally irritated with the whole thing. It just seemed so contrived and so limited and so formulaic and so hermetic—the rest of the world had a lot to say (about the [Vietnam] war, for instance), and minimal and conceptual art just cut everything out. I really wanted to bring some real world concerns back in. My main interest was in a non-Western engagement. So was Bob's. Other people in this "movement," which eventually became a large group, were all over the place in terms of what they were interested in. So I think everybody borrowed, to some degree, from one another. I borrowed a lot of stuff from the feminist area, which would be "borrowing" in the sense of quite literally using things that were associated with women and women's work: for example, taking Christmas aprons and making them into a piece like *Progress* [1978] (a piece now owned by Bruno Bischofberger), which is made from flocked Christmas aprons and other kinds of gauze materials supported by horizontal bamboo pieces that form a kind of kite.

RC: Did you show this work with Bruno Bischofberger initially? Is that how he ended up with it?

KM: I did a show with him in 1978 called *China Trade Leisure Traffic*. I guess he had closed his gallery for a period of time, and it was the first show of his reopening. It was an odd experience, actually, at the opening. It was hugely attended, jillions of people. Everyone was very well dressed ...

RC: This was in Zurich?

KM: Yes. I spent the whole evening just kind of wandering around the opening, because nobody said anything to me. I was outside having a cigarette, and this person came out, and we were talking, and he said, "Oh, you're the artist. Everyone inside was looking for the Korean!"

RC: Oh, because of "Kim"? Or because of "China Trade"?

KM: All of the above. It was peculiar. The show at Bischofberger was cloth pieces and gouache on paper pieces; there were no gauze pieces. In 1978—I don't know if it was before or after my show with him—he bought fourteen or fifteen works from Holly, just a broad sampling of things that included *Progress*. *China Trade Leisure Traffic* was a kind of exploration of what the boundary would be between Western and non-Western sensibilities by compressing historic ideas about the "China trade" of the sixteenth to nineteenth centuries with contemporary "leisure traffic."

*Collection Applied Design*, the shows I did at the La Jolla Museum, in New York, and in Miami some years before, played around with Chinese imagery in different ways. There was a piece called *Serve the People* which simply had ping-pong paddles in it as part of the design; there were Chinese mountain landscapes as imagery that would be a portion

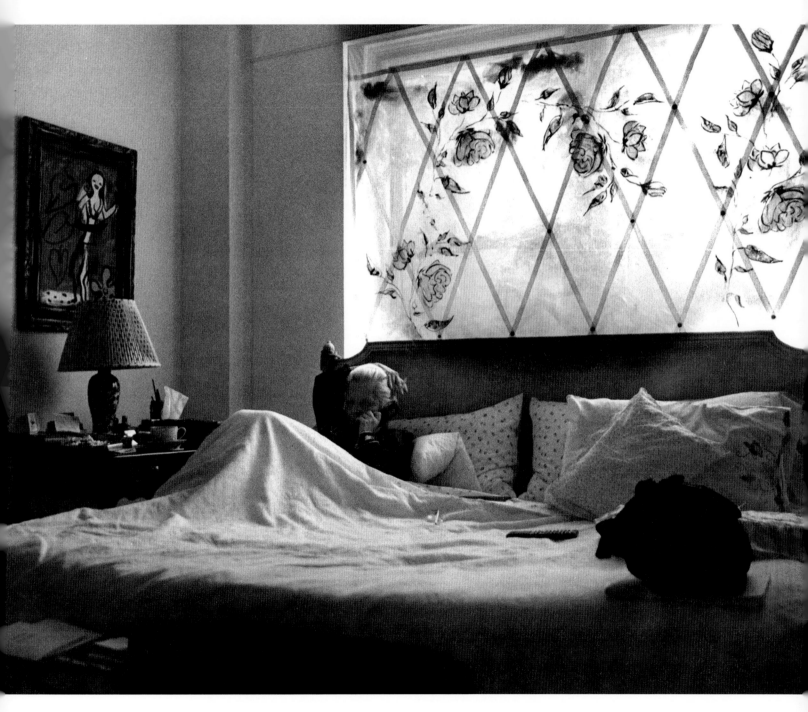

Opposite, top: Holly Solomon at her gallery. Courtesy of John and Thomas Solomon

Opposite, bottom: Exhibition brochure, *Collection Applied Design: Kim MacConnel*, La Jolla Museum of Contemporary Art, March 19–May 2, 1976

Holly Solomon in her bedroom with bedspread and curtain made by Kim MacConnel; *Hula Girl* (1986) can be seen on wall at upper left. Courtesy of John and Thomas Solomon

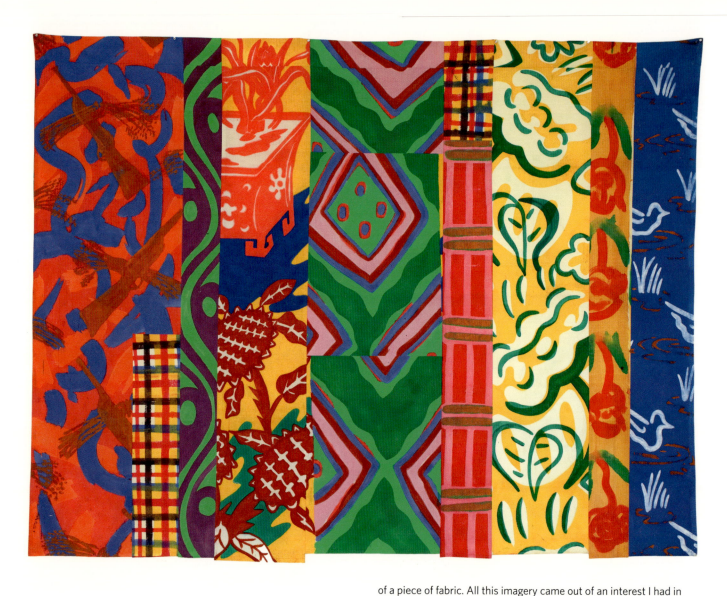

Kim MacConnel, *Red Lantern*, 1975
Acrylic on fabric, 84 x 108 inches
Museum of Contemporary Art San Diego,
Museum purchase

Opposite: Gordon Matta-Clark, *Splitting* 32, 1975
40 ¾ x 30 ¾ inches
Courtesy the estate of Gordon Matta-Clark and
David Zwirner, New York

of a piece of fabric. All this imagery came out of an interest I had in Chinoiserie that was really pretty much opened up and extended by a British art historian, Hugh Honour, who wrote a book called *Chinoiserie: The Vision of Cathay* [1974]. What interested me about that book was that Honour traced the development of the Chinoiserie movement within the Rococo as it spread through Europe, from Italy northwards to Spain and in France, and eventually into England. It moved from being about fêtes, or parades, and ended up being about gardens. So this broad-ranging aesthetic engagement being introduced into Western society—and certainly not in a very coherent way—was part of the tea trade, and people were interested because it was exotic and not like any of the things that they knew.

What interested me about all this was the flip side, which was that from Louis XIV on down, in the late eighteenth century everyone thought China was under a benevolent dictatorship. This was echoed in the late 1960s and early 1970s when the intelligentsia within the art world and within the fields of literature and philosophy felt the same way about Maoist China. There were discussions of the "Great Leap Forward" and the peasant movement, and it was extremely fashionable to be part of this engagement. This 1970s attitude was, to me, an absolute parallel to the eighteenth century looking at China in the same way: it was exotic, and therefore it was more correct, in a way, or more interesting than what we had here. And certainly as a comparison, in the early seventies that was in fact true, because Nixon was running about like a potentate, essentially. So there was that parallel that I found really interesting. Nearly all of the work in Collection Applied Design [the 1976 exhibition] comes from that interest.

Red Lantern [1975], a piece owned by MCASD, references the Chinese ballet titled Red Lantern. Within it are crossed sheaves of wheat and guns you can barely see within the fabric. That is a reference to eighteenth-century Bizarre silks [a type of weaving technique seen in the late 1600s to mid-1700s and centered in France and Spain], which utilized decorative techniques to embed images; the imagery was so complex it was difficult to disentangle the motifs. So, to me, that's the power of decoration. It's indirect, in a way: if you look at it, it kind of evolves, it pulls itself out, but it has the ability to carry meaning, both positive and negative. It reinforces the state or you can use it to tear down the state. And so it seemed to me to be an interesting fulcrum between revolution and maintenance of the state. That was really the core of it. And Holly really got that, she absolutely got what I was playing around with. That was her kind of real core bohemianism. Here she is, this fairly wealthy collector whose husband made bobby pins—his company was Solo Hair Products. They collected Pop art and were viewed as collectors—they're not steering society, they collect art. Well, actually, Holly was steering society and she was interested in the power of art in terms of changing the conversation between the power at the top, collectors, and the power at the bottom, artists.

RC: I'm sorry I didn't have the chance to meet her.

KM: Well, she was both a bit caustic and very sweet. She could be very argumentative and at the same time a muse, always pushing me and sometimes ticked off at me because I didn't do enough of the social thing and didn't want to come to New York to do it. She was right in many ways, but to me it was about the work, it wasn't about the personality (even though I know personality is a big part of pushing the work). Any difficulties in our friendship were over that issue, but otherwise she was hugely supportive right to the end.

RC: There was such a range of approaches in the work of artists that Holly Solomon represented—what would you say characterized the gallery overall?

KM: The connection would be the breadth of her interest, which I can only describe as "bohemian." It really comes out of her engagement with 98 Greene Street as a performance space where Hell's Angels would ride their motorcycles up the stairs to the loft as part of a piece. She came out of this Kaprow-like engagement, on one hand, and the celebrity flattery of Pop. Part of that as well was the kind of flipness of Lichtenstein, who she really adored as a friend and as an artist. And yet she also really liked people like Gordon Matta-Clark and really supported him tremedously in terms of doing whatever he wanted to do. So what was he doing? Well, he was tearing down the establishment or sawing it up, and so Holly's connection to that and her connection to someone like me or Bob was in that vein. Maybe we were out on the edge … not as a direct action, certainly, but we were still interested in the same kind of social change, the kind of strength of social change that could come out of art-making versus some other kind of activity. At the same time, she adhered to a very strict idea about social propriety—that's what I meant when I said she was very upset with me when I wouldn't go to a cocktail party, because that was a big part of it. She was engaged in this idea of … not necessarily "revolution," but revolution in terms of art-making, like, push the boundaries of this thing.

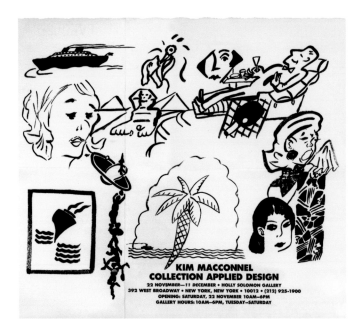

Amy Goldin wasn't really rebellious in that sense. She was just brilliant, and her intelligence was extremely convoluted in terms of how she would arrive at a point. It wasn't revolutionary in that sense—she wasn't interested in turning the house upside down. She was interested in analyzing why the house was being turned upside down or why it should be, but she wasn't interested in doing it necessarily as a social act—she was interested in it as an intellectual engagement, as an art historian and critic. So when I said it was kind of like oil and water between Holly and Amy ... both were huge muses to me and were people I could really talk to and bounce things off of. I would have these long conversations with each of them about this kind of stuff, and we would argue vehemently. But never the three of us together—it just simply wouldn't happen.

RC: But we all have friends we love who don't love each other.

KM: Right, exactly. So I imagine Bob's relationship with both Amy and Holly was very different from mine. In terms of the gallery, some artists felt like they never got the kind of support they should get from Holly or that she was way too critical of some whereas some others could do no wrong; I know some people really didn't feel like it was a very tightly bound group in that sense, but to me, she was covering her bases, in the sense that she was diversified. She bet on Bob and me and Valerie, Brad Davis, and a number of other people early on, but she also brought along Gordon, certainly, and I think Gene Highstein and Joel Shapiro and many others. The number of artists who have been through her gallery is quite amazing, and she really did like it all. She would buy something from everybody, because she really was a collector. She really wanted to be part of what was happening—and she had a great eye for that—but at the same time she was a savvy businesswoman and wanted to hedge her bets.

It was an interesting time between 1974 and 1978 in part because of the state of the economy and the transition from Nixon to Carter. The kind of image that is attached to the Carter years is that they were not robust enough, all cardigan sweaters and modesty and humility. It was an incredibly inventive time in the art world, yet at the same time there was the gas crisis and the economy falling apart in 1974. Holly opened a gallery right in the middle of it—which was great for us as young artists. It couldn't have been a better time, because there was no market for anybody more expensive, and people wanted to put their money somewhere and see if they would do better than the inflation rate at the time, so they would say, "OK, I'm going to bet on Bob Kushner and I'm going to bet on Valerie Jaudon," and that's the sole reason, I think, that we actually kind of moved forward a little bit within the New York art scene—that, and help from Europe. The European newsletter *Art Actuel* put us on the map in terms of collectors, because evidently lots of people read it in Europe, particularly in Germany, and to some degree in France. So that's how Bruno became involved and Daniel Templon and Thomas Ammann and Rudolph Zwirner. That was also the cause of our demise in the end: when the economy got better, our prices had gone beyond a kind of speculative engagement. The new speculation was on Enzo Cucchi and the Transavangardia, and right on the heels of that were the New York neo-expressionists and German neo-expressionists. Everybody just poured their money into it.

RC: Was that in 1981?

KM: Earlier, about 1980.

RC: But Holly never really went for that work, did she?

KM: No, not really. Although I know she included Julian Schnabel in her shows.

RC: I could see that, though. Of all of them, he's very ...

KM: He was very affable, actually, and she liked him. She got along very well with Julian and vice versa.

RC: The 1980s ...

KM: In the eighties people's opinions of the seventies was like it was just the most embarrassing decade ever.

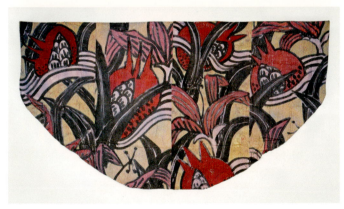

Opposite: Invitation to opening of *Kim MacConnel: Collection Applied Design* exhibition at Holly Solomon Gallery, November 22–December 11, 1975

Top: Valerie Jaudon, *Jackson*, 1976
Metallic pigment in polymer emulsion and pencil on canvas, 72 1/8 x 72 1/8 inches
Hirshhorn Museum and Sculpture Garden, Smithsonian Institution, Gift of Joseph H. Hirshhorn, 1977

Bottom: Robert Kushner, *Pomegranates and Lilies*, 1974–75
Acrylic and ink on taffeta, 91 x 173 inches
Courtesy of DC Moore Gallery

RC: I could see that in a way, but in terms of art, the 1980s in New York ended up being much worse.

KM: I think so too.

RC: Completely appalling ... the 1990s were a tremendous relief. Speaking of the 1980s, your gouaches from this period are wonderful.

KM: Thanks.

RC: Were you making this kind of more intimate work on paper all along?

KM: Yes, from the early 1970s onward I was making gouache-on-paper pieces, like this "torso" piece, which was really kind of academic. I was living in Paris, and all I did was go to museums and come back to my place and try to paint. They were just little things because we traveled around a lot, but I wanted to keep doing it, and so I would go to the Cluny and look at a fabric hem or something like that and put it together with a Picasso torso in some way, or some Romanesque church design, or something like that. My interest was in what pattern was and how it could be used in a composition. What are the boundaries? How do you maintain some kind of order, or do you? Do you overlap? Everything side by side? All of these issues ... they're not necessarily technical, but they were the sorts of surface concerns that a painter would have. That was in the early seventies, but by the time the eighties rolled around, I had worked through many vehicles and was moving back toward this idea of composition. The strips were a kind of composition, obviously, but the strips are strips, and there is a structural engagement. Things jump around and they move across, but you're not working compositionally, in a traditional sense.

RC: It's like a grid, but what do you call it when it's only half of the grid?

KM: That's exactly right. One person whose work I really liked was Raoul Dufy, in part because he was viewed as being a dilettante, a fop, or whatever, painting rich people at Henley and Ascot and stuff like that. But I also thought he was very subversive, in part because he was so flip and kind of illustrational. In a way, it's like Julian Schnabel's portraits: Who would want a portrait of themselves painted on plates like that? What does that do for you? He's not a good painter or draftsman, so it has to do with something else, and what is that something else? Well, it's this other issue of status and class and all that. So when I got into Dufy, I liked the way he used local color. Just slap some color down, arbitrarily almost, and paint through it, and that changes the nature of the depth and surface and brings in something that is actually an abstract shape within a representational form or context or scene. Dufy, also, is a guy who was

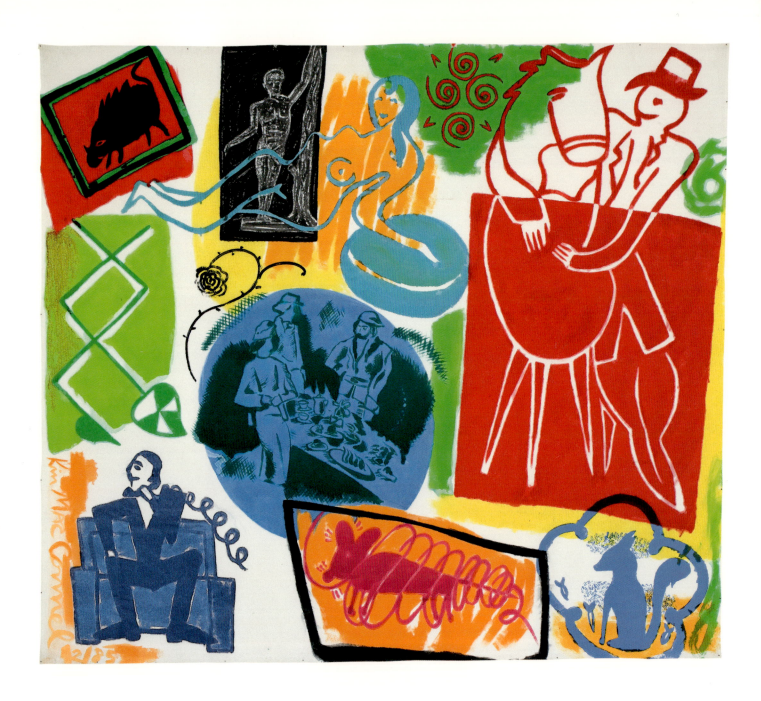

Kim MacConnel, *Horsey Set*, 1985
Acrylic on fabric, 94 x 108 ¾ inches
Museum of Contemporary Art San Diego,
Gift of Laurie and Brent Woods

working with textiles in a way that was different from Picasso and different from Matisse and yet was both modern and very traditional. There was something offhanded there, and the offhandedness interested me.

I liked Dufy's work in part because I had basically spent a decade copying from these ad books as though I was doing Chinese calligraphy. I was painting all of these graphic images with a brush, which was not really how they were composed. It's a little bit awkward on a small scale, but when you blow it up it becomes *really* awkward. What I liked about Dufy was that I could borrow that so-called local color, those blocks of color, and insert these things in a composition; this helped control the composition and keep it from falling into linearity and illustration. That's what keeps his work from falling into illustration (that and his offhandedness). I basically was picking up on that and trying to extend it into a painterly vocabulary that moved me out of one kind of image-making into another fairly seamlessly. I'm not dropping things all together, and it doesn't look as though I have. It just looks like it shifts some way. These works are big pieces on bedsheets, but they came from gouaches that measure 25 by 32 inches (or something like that).

RC: So the Museum's painting *Horsey Set* [1985] falls into this category.

KM: It's interesting, because in a comparison of meaning and composition, a piece that will be installed near *Horsey Set* in the show, *Good Work* [1979], is a strip piece that uses found fabric like this tiger stripe; there's also another printed thing that I painted cars over; a textured piece of fabric with a depiction of a mansion and a swimming pool; and in the center is a hat-wearing Chinese farmer holding Hubbard squash on top of tiger-stripe fabric. So that, to me, going back to that kind of ... again, I don't think many people would get the political reference here: it's a Chinese peasant and a tiger—boil that down and you get "revolutionary." Maybe it's a passé notion of revolutionary, but it's still at the basis of this definition of the word. That's what I kind of played around with in terms of these kinds of imagery, but not everybody is going to get that. But if you read "mansion" and "swimming pool" and you read "tiger" and "proletarian peasant," maybe you do get something—it's a kind of rebus.

So if you move into the imagery of *Horsey Set*, created six years later, it contains simply a cartoonish figure hugging a horse: it's an equestrian hugging a horse. It's schematic, almost abstracted, and it has a big block of red under it that bisects the form and sets the tone. I'm simply talking about a horse and rider, but I call it *Horsey Set* because it denotes some sort of social order. It's hard to read some of the other things, but there's kind of a 1920s flapper party going on, so it's very much dated. There is a kind of schematic nude female overlaid by a kind of Greek figure, also fairly schematic. Although the thing keeps fracturing as a whole, the composition pulls it back together so you don't leave the thing—you just keep going around and around and around making different kinds of associations. In a painting, there is one association that I might pull out as the dominant one, sometimes just descriptive, but primarily with some kind of underpinning ... maybe not just that single work but extending into five or six pieces or maybe the whole show.

A show of mine that is an example of this was called *Luftgeschaften*. *Luftgeschaften* is Yiddish, and evidently (because I don't speak Yiddish) it means "air business." It was in an article I read about a writer who was talking about his success, and he referenced his father, saying, "You know it's like my father. He could never make any sense out of my choosing to be a writer, and he would just say, 'air business, *Luftgeschaften*! You can never make anything out of it!'" You know, it's without foundation. I really liked it as an exhibition title because the paintings I was making at the time were in relationship to the buildup of this confrontation between Reagan and the Soviet Union and the kind of brinksmanship they were playing at. So *Luftgeschaften* then took on a new meaning in this context. That's how I would play with something. Every piece within that show would be related to this in some kind of way, like a title would be *Indispensable* and it would have an aspirin bottle as part of the imagery, or it would be *Collectable* and "collectable" would be bombs dropping. *Nutritious* was another piece, where obviously the irony was that missiles are hardly nutritious. In that sense, I was really trying to maintain a kind of subversion within the work because it was so bright and colorful, and as a lot of people have said, "pretty." It was happy, but underneath it there is something else, too, and that to me is the subversion.

RC: Well, beauty as a delivery system for more difficult ideas is an established tactic.

KM: There are people out there who know how to work an image, who are not afraid of color.

RC: But not all of them are using it to deliver something else.

KM: You know, to me, this is certainly the hallmark of the postconceptual movement. Lots and lots of artists have certainly worked in the same vein over the years—Stuart Davis comes to mind, perhaps. But to me it's the hallmark of post-Vietnam or late Vietnam/conceptual practice moving into postconceptual practice. What are you making work for? What are you trying to convey with what you are doing? Is it just about beauty? What part of beauty is interesting, and how far can you extend that? What are you interested in saying?

RC: I've been thinking a lot lately about what it means to sustain ... I was about to say "a practice," which sounds a little pretentious, but you know what I mean—what it means to keep working.

KM: I think it's really hard. On the upward trajectory it's not easy, because it's mostly just a tremendous amount of work under pressure because someone is interested in it. But when people lose interest, which is mostly kind of inevitable at some point, then what are you going to do? Do you want to keep doing this? And why do you want to? If you wanted to change, what would you want to change? What would it be? So things keep changing in terms of why you do this thing … and part of it is to make money, because I wouldn't know what else to work at, frankly. That's partly how I got started as an artist: I couldn't figure out anything I could do other than maybe do this. I think it's really difficult to be faced with having to start over occasionally, or serially, and be interested in that. How do you keep this thing going when you might not even be interested at a certain point, and you need to bridge to something that actually makes it interesting again. It's almost easier to have people say, "I'm not interested in your stuff anymore"—then you have to reinvent and think it through. But if no one says anything, then what is it they like? And where do I keep going? I think artists from certain generations have built-in bridges, and with this "post-studio" thing, you go out and reinvent every new engagement, which makes it a lot harder. It becomes a challenge for any artist—I don't even want to just say "artist," any *person*—trying to do something from scratch. That's really difficult. So I'm quite surprised I'm still doing this.

RC: It seems as if you've created a situation for yourself where everything is integrated.

KM: There is some surprising consistency over the years. I think teaching at the university [University of California, San Diego (UCSD)] really helped. To put that in perspective, I think it would be very difficult to live here and be an artist and not be attached to an overriding structure that helps you or forces you to get out there and show what you produce. You don't move upward in universities unless you're fairly aggressive about trying to take what it is you have been interested in and turning it into something that can be judged by somebody on the outside. If you're just working as an artist, who cares? I mean, if somebody is interested and they come by and happen to see your stuff, or if you're motivated enough or ambitious enough to put it in front of somebody, something might happen. If nobody is interested, maybe nothing will happen, and maybe you just don't work anymore. I know many really good artists who have come out of graduate schools who haven't continued making art because there was just not a real reason to do it. Maybe early on in a career you have that engagement, but there are also these points along the way where, unless there is a structure you are a part of, it's very easy to drift off. That structure is New York or L.A. Here, it's the university. It's a funny occupation, and it's really embarrassing to put all this stuff out there about yourself that has something to do with you—you risk people not being particularly interested in it. So I think the university really helps in terms of maintaining these kinds of standards across all disciplines of accountability. In a way, it is this accountability that forces you to think about what you do and maintain currency within what's going on out there.

Regarding the *Woman with Mirror* series [2007], for example: I really was thinking about how to follow up on a show I did at Rosamund Felsen's gallery [in Los Angeles] in 2004 which was about working with a really limited number of forms. During the latter part of the 1990s I was doing big photo pieces, which some people were interested in (though not very many, so it seemed like my little hobby), and I kept seeing if I could push it and keep it alive and do something with it. In terms of painting, I really wasn't doing any, but then my friend, the artist Izhar Patkin, wanted to open an interesting restaurant in New York that served a mix of Palestinian and Israeli cooking as a political statement, but also to be a place where artists could hang out, kind of like a new Max's Kansas City. He wanted it to be kind of Near Eastern but not locatable in terms of an aesthetic, and he asked me to come and paint some of the furniture. I didn't want to spend a whole lot of time on it by "hand-painting" everything, so I made kind of a production line. I painted the chairs with paint rollers; I had to do it fast and it had to be very simple, so the pattern had to conform to the dimensions of the paint rollers. You'd go this way this far, that way that far, and that's it, and then you move on. I think I made about 100 of these chairs, and I had a good time doing it. I hadn't been painting for at least five years, and I thought, "Gee, this is really kind of interesting." And then I was hired [by Itzhar] as a consultant on an Ian Schrager hotel in Miami Beach called the Shore Club. My task was to paint some banquettes around the pool, do some seating areas, paint the settees and the chairs, and then paint a whole bunch of throws that we bought (from an IKEA in New Jersey), which were these Greek cotton throws that had a little bit of texture in them. We went back to his studio, which is enormous, and spread them out on the floor, and—again with rollers—I just painted these very simple designs. They all went to Miami. Some were taken away by guests; the rest were blown away by a hurricane.

At some point I had to say to myself, "You know, this was really kind of fun. It was challenging, it was really interesting, but these are really informal structures. Could you take this and translate it to painting, to a canvas? As an abstract painting and have it work?" So that show at Rosamund's in 2004 was about trying to see what medium worked, what form worked. Some of these pieces were made with house paint on very small canvases that were less than two feet square; the canvases ended up being installed as a band, and as you walked into the room it opened up to being a strip, and the strip was composed of individual parts. The only other painting in the room was one piece that was pulled out and placed on the opposite wall. You couldn't look at it at the

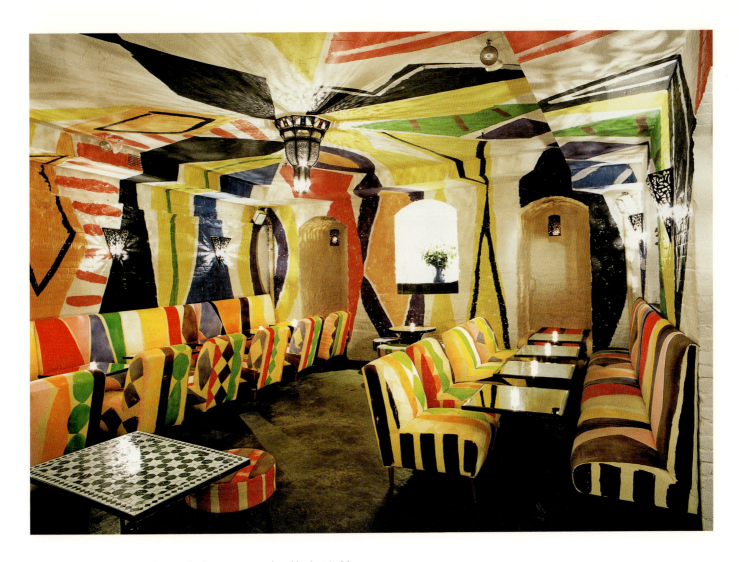

same time as the other work—you had to turn around and look at it. My instruction to Rosamund was that if anyone was interested in a piece, it should be separated out and looked at alone on that wall with the former solo piece and then put back into the group.

In addition there were enamel pieces that were also like a band in a way, but a truncated band made up of very simple architectural abstract shapes like triangles and squares and diamonds. Then there were these big cloth pieces, abstracts, that were an attempt to link up with the work I was doing in the early 1970s [the *4 Pattern Dub* series]. I was trying to see if could move away from a depiction of something as a form, even a Near Eastern textile, and move into something that referenced it or attached itself, just barely, to it—like Matisse attaching himself to Morocco, just barely there. I was interested to see if that would work as a loose cloth

Kim MacConnel, interior of Chez Es Saada restaurant. Reproduced in "Rock the Casbah," *Interior Design* (March 2004).

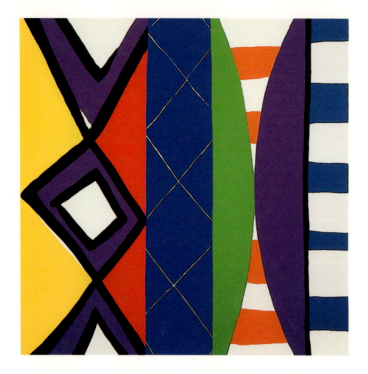

Kim MacConnel, *Woman with Mirror, #4*, 2007
Latex acrylic on canvas, 48 x 48 inches
Courtesy of the artist and Rosamund Felsen Gallery, Santa Monica

Opposite: Kim MacConnel, *Clown*, 2005
Cast aluminum painted with enamel,
32 x 9 x 5¼ inches
Museum of Contemporary Art San Diego, Museum Purchase, Louise R. and Robert S. Harper Fund

hanging, and Rosamund afforded me the opportunity to do it and was very encouraging. It was really great to do it, and it was a terrific show; I think people really liked it. Afterwards I thought, what do I want to do now? I found that I couldn't repeat any of the three engagements as a form to go forward with, so I decided to just do some sketches. I started doing little six-by-six-inch sketches on loose scraps of paper, just abstracts. What I was kind of playing with was some of my earlier work and some cloth strip paintings from the ad books and the lace design books, seeing if I could remember enough to just invent and do these again, and they started to change. I moved very quickly from doing strips to doing forms that could take up the whole space. And I started thinking about Picasso.

RC: What about him?

KM: What would be a meaningful engagement? Even if you are meaningfully engaged, can you be meaningfully engaged aesthetically in a way that finds resonance within the very arcane and complex structure of critical engagement? Picasso, while a huge figure historically, is not a driver of contemporary art for the most part. I thought it was appropriate to talk about this, to use someone like Picasso as a vehicle for this kind of discussion within a body of work. It's not a thesis, it's just simply something that drives a body of work in terms of invention. That became really interesting for me to step into, in part because of my own use of abstracted imagery within an abstract format over time, similar to Picasso's engagement, which begins and ends with this idea of imagery within an abstract format. What if we take Picasso's subject and remove it from that background fabric of his paintings? What do you end up with? Just background patterns without a subject? In Picasso's *Les Demoiselles d'Avignon* [1906], he is essentially lifting tribal masks from the fabric of indigenous African society. My idea was to play with the opposite and lift the figure out of the "fabric" of his painting. The painting by Picasso that came closest to this idea was *Girl Before a Mirror* [1932]. If I applied this title to my sketches of "patterned backgrounds," it suddenly gives content back to the piece, and suddenly all the forms that are in it are figurative, or they're abstract, and they flip back and forth interchangeably. The conceptual or postconceptual play is that I went ahead and did it twenty-seven times.

RC: Twenty-seven?

KM: You know, asking, "How many times can you do this kind of thing?"—a kind of absurdity that Bill Wegman might use. Or Vito Acconci.

RC: But there's something also very sensual about the repetition and variation of the forms and the colors. "Absurdity" is not the first thing that comes to my mind looking at these paintings.

KM: I think that's the power of the visual. A good composition is worth a thousand words. There are just so many linking elements: the diagonal hatching in the Picasso background of *Girl Before a Mirror*, that's the wallpaper, or something like that; the mirror, this kind of elliptical shape; the figure, a kind of curvilinear shape. If you can accept that shape as being something, then can you accept this diamond as being something? It's a female figure or it's the harlequin from his very early Rose Period. How far can you take this thing as a readable form within this context, and where does it break down? You know, I have one piece in this series that, to me, never really worked.

RC: So there are twenty-eight?

KM: No, I painted over one—waste not, want not. So the forms might be two figures or it might be a reflection of a figure in a mirror. While I'm doing the sketches I'm kind of thinking about that, but I'm not *really* thinking about it. It's really when the sketches were transferred to the canvas that these relationships actually started to pop.

RC: Changing gears a little, one thing we haven't talked about yet is your collecting beach trash and making assemblages, and the trash installation that you are making for our show—*Selections from The Beach Collection*—the date for which will be "1975 to the present." It seems to be an ongoing concern.

KM: I started collecting plastic beach trash in 1975. There was a lot more beach trash in those days.

RC: Was there?

KM: Yes, I would find these … just strange little things, rather than sea-shells. Some odd thing would float in and I would be fascinated by it. Mostly it was melted things, like boat parts that had burned at sea. Also, traveling in other countries, the stuff you find on the beach is quite remarkable, particularly in India or West Africa. I came back from a trip from West Africa in 1982 with a carry-on bag filled with beach trash. To compact it, everything was wrapped within each other, so it was a deflated ball and another smaller deflated ball and something inside that, etc. Some of the things I found there are called *Ibeji*. In Nigeria, particularly, *Ibeji* are twins—it's a talisman totem, a charm—and it's a way of protecting children: a child has a twin, and the twin is an *Ibeji*, so if there is black magic or some kind of problem, disease, what have you, the *Ibeji* takes it rather than the child. There are carved ones that are traditional, but the contemporary ones are little plastic figures, and they look like little Dutchman. They have the little flat hats that Dutch men used to wear in the nineteenth century.

RC: Did the Dutch colonize that country, or is that random?

KM: Random, I think. Well, the Belgians were nearby, and of course, the British—Nigeria was a British colony. In any case, these *Ibeji* end up on the beach, so if you beach comb you find these weird things throughout West Africa. So I came back through customs in New York with this ball of stuff, and the customs agent looked at what I had in my suitcase and asked, "What's this?" I said, "It's beach trash from Nigeria and Benin." And he just rolled his eyes; he did not want to get into it. My interest in collecting beach plastic is long term. Apropos the clowns made from beach plastic, there was a show at the Guggenheim in 1993 which I think was called *Picasso in the Age of Iron*.

RC: That was a great exhibition, curated by Carmen Giménez.

KM: Terrific show. It was mostly sculptures made from scrap metal, abstract forms made from the detritus of industrialization. While I was

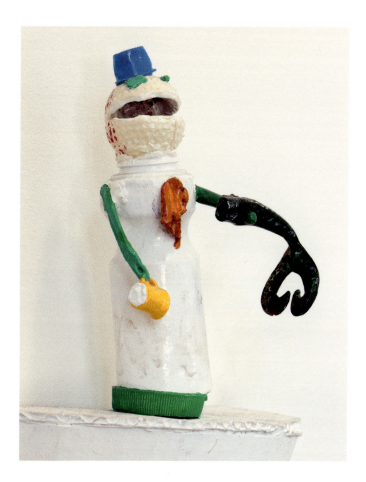

walking through the show, I thought it was really interesting that this was rubbish from the beginning of the twentieth century, in the lead-up to World War I, and that in 1993, when the show happened, everyone was starting to think about the end of the twentieth century. I was also thinking about clowns, because clowns are about as far from abstract contemporary art as you can get (plus, they're despised). I was thinking about the detritus of the buildup of the industrial age and the detritus of the end of the plastic age, essentially. Where does this detritus reside? It resides on beaches, it's the flotsam and jetsam; I used to call them plastic seashells. That difference in waste, to me, brackets the last century.

In response to that exhibition, I decided to take all of the beach trash I'd been collecting and make clowns out of it. I had just moved into the new studios at UCSD, and I took all my beach trash and dumped it in the middle of the floor of the studio. I sat down with a glue gun, and I started making clowns out of all the parts. I made about 400 clowns, and I showed at least 200 of them with Holly Solomon in a 1994 show called *Age of Plastic*. I made little white sconces for them. There was no color other than the plastic. I made four tiers of these around the room, and there were pedestals in the middle of the space, so it was overwhelming: no matter where you looked, you were looking at trash and you were looking at clowns (although "clowns" was a very loose definition for

these figures). Lots of people would just come into the space and laugh, and other people would come in and wear a look of complete consternation. Then I made these paintings that went with them, which were kind of send-ups of … I wouldn't say contemporary art, but more of modern art. There was a send-up of Jim Dine, a big love piece—two hearts, one inverted, and a clown sitting on top of that on a pedestal. There was a Carl Andre harlequin kind of piece. There was a Warhol from his "Egg" series which had a clown on it called Piggy because it was a rolled-up placemat that had cartoon pigs on it. There was a Daniel Buren, it was a red striped piece. They were send-ups of minimalist and Pop art. Some of them—actually, most of them—were chosen for the product name on the discarded object. There were lots of little in-jokes—in-jokes with myself, anyway; I laughed at them.

RC: Super in.

KM: Jean [Lowe] had a show at MCASD's downtown space around 1996, a midcareer retrospective. We couldn't think of anybody to show work in that corner room … other than me.

RC: It's a tough room.

KM: So I put all the beach trash in there and called it *Selections from The Beach Collection*, as if the beach was an art collection: The Beach Collection. It's a pretty obvious piece. Except for the connection to the *Age of Iron* show as a kind of bracket for the clowns. The pile of stuff is just Robert Morris's detritus pile.

RC: His *Threadwaste* piece.

KM: It's interesting to look at as a pile. It's actually kind of profound, because parts of it are gross and parts of it are fascinating. You start seeing the little teeny-weeny detritus, little tiny tiny pieces of plastic that continue to deteriorate. And the sand residue: although they have been cleaned, they still have sand that keeps shedding. It's just like taking a concentrated beach walk. It's really revolting but at the same time really just incredibly beautiful, and it's a very strange piece. I'm very happy to have the opportunity to play it out again, with even more stuff.

RC: With more stuff, in the Krichman Gallery in the La Jolla building.

KM: It's a hard space.

RC: It's beautiful, though. It's wonderful that you've designed this show specifically for our La Jolla building. I think it's the only way to deal with that building.

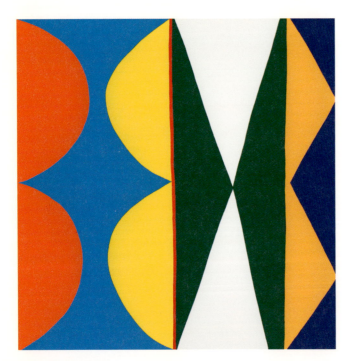

Kim MacConnel, *E4*, 2010
Enamel on wood, 46 x 46 inches
Private collection

KM: It's hard to deal with it any other way. I got the idea looking at Bruce Nauman's exhibition there in 2008 [*Elusive Signs: Bruce Nauman Works with Light*]. I realized, "Of course! Make this about the experience, not chronology."

RC: That's the conclusion we came to also … can you talk about your most recent body of work? To me these are some of your strongest paintings.

KM: Making these latest enamel pieces is like a game, and the game is immediate—you simply start painting and you invent from what you make. With the enamel you have to work flat rather than vertically. It's kind of unforgiving; you don't go back. In a way, it's forcing a kind of commitment to a procedure and a material form that I've spent most of my career avoiding because it's unforgiving. A lot of my work is about approaching art-making peripherally, to avoid standing in front of a blank stretched canvas trying to paint something that carries so much weight. It's everybody's white canvas nightmare.

RC: It's the same with writing.

KM: Exactly. It's much easier to find some peripheral route into this thing.

RC: Something oblique.

KM: Exactly. That was what was interesting about moving from the painted chairs at Chez Es Saada [Izhar Patkin's New York restaurant] to paintings on the wall. Those were completely oblique and free from stress, and therefore fairly easy, as opposed to a much more serious engagement in which this is judged in a very different context with very different signposts, like Matisse or Ellsworth Kelly. You have to take it further to see if it still holds up within that critical system and then maybe take it even further. Since 2004, each step of this engagement with a couple of zigzags is the one that ends up being the most interesting. Around *Woman with Mirror* are two bracketing bodies of work that mostly have to do with material. In one group I used acrylic with marble dust mixed in, which really flattens out the plasticity of the paint and makes it absorb light like gouache. It gives it a much different texture than house paint, also very flat. Then I did several pieces that were just acrylic, but layers and layers and layers and layers. That was a little too much labor, frankly, for me, but you see a lot of striation from the layering, because a lot of the acrylic paint is translucent or transparent in some of the colors. An interesting experiment, but I kind of liked the flat opaqueness the marble dust afforded.

RC: We don't have any of those works in the exhibition.

KM: No, but that was the jumping-off point for the *Woman with Mirror* series. I decided I was going to use latex acrylic house paint to do *Woman with Mirror*. But the enamel has stuck with me as being the most interesting direction forward, for now. This has developed into a body of work called *ABRACADABRA* [2010], which will be shown at Quint Contemporary Art [in La Jolla] this fall—like *E123* [2010] in this MCASD exhibition, it is magical.

RC: A nice thing about an exhibition like this is that people will have a chance to see your work together.

KM: It's wonderful to be able to think about what generates work and to think about this stuff in the past, about the links that pull things forward or connect them over time. This exhibition has afforded me an opportunity to look at the work in terms of abstraction as an underpinning or a foundation or a subject; this is an avenue that, for me, has never really been explored as a binding theme. The theme of the Santa Monica Museum of Art exhibition [*Parrot Talk: A Retrospective of Works by Kim MacConnel*, 2003, curated by Michael Duncan] was the idea of framing. Because so few pieces would actually fit in that show, I was looking around for a cohesive means of linking so many different kinds of work together, such as a carpet, photos from Africa, and a painting with frames stuck on it. With a limited representation of a career, how do you hold it together? We chose framing as the theme. This MCASD exhibition is big enough that it is possible to look at different threads, particularly of abstraction, from the beginning to the present.

RC: Installing this will really be something.

KM: I don't think most people would think of me as an abstract painter, so it's kind of nice to have the opportunity to show that I played around with some of these ideas way back when, and I'm still playing around with them now in another way.

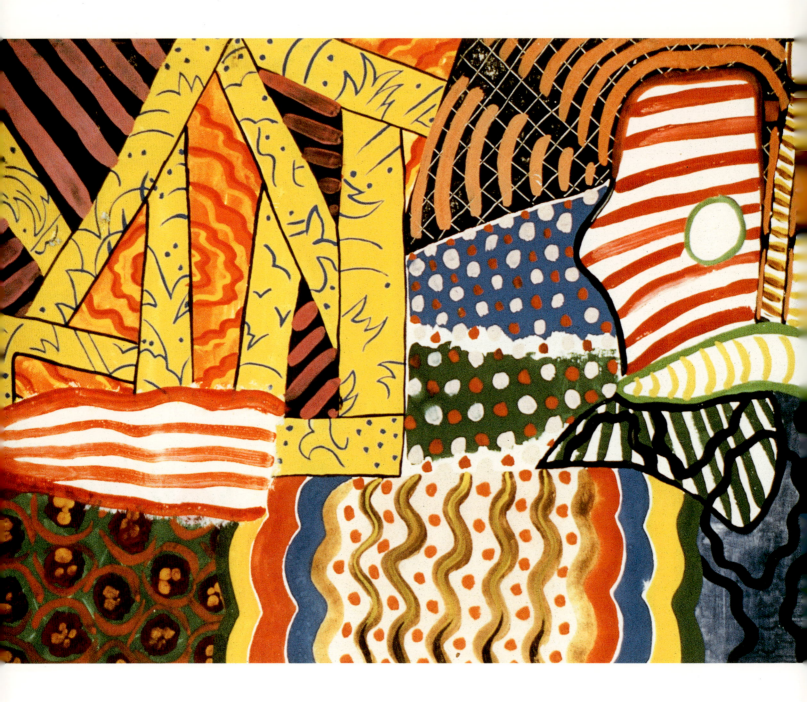

fig. 1
Kim MacConnel, *Untitled (Picasso Torso)*, 1971
Gouache on paper, 15 x 18 inches
Courtesy of the artist (not in exhibition)

# MacConnel Modern:
# A Collection of Applied Designs

RICHARD D. MARSHALL

Kim MacConnel has made a definitive contribution to the evolution of ideas and forms in contemporary art. More than thirty-five years ago, he emerged in the art community with a new and fresh type of expression that was bold, colorful, joyful, and subjective. MacConnel referenced nontraditional forms of visual expression and employed unusual formats and configurations in a way that was surprising and inventive. The late 1970s was a decisive period in recent art history: many artists were exploring alternative forms of expression that utilized language, photographic imagery, borrowed subject matter, social and political content, and expressive gestures. A shift took place, away from the Pop, minimal, and conceptual strategies that had dominated the 1960s and early 1970s, and MacConnel was at the forefront of the movement to infuse new art with unexpected content, meaning, and references that expressed the interests and concerns of a new generation of artists. An overview of MacConnel's production reveals an artist with a clear and integral vision that has evolved and grown during the course of his career.

One of Kim MacConnel's earliest pieces was created in Paris in 1971, during his first year abroad after completing graduate school at the University of California, San Diego. This small gouache on paper, *Untitled (Picasso Torso)* (fig. 1), is dazzling and dizzying in the way it encapsulates and foreshadows many of the formal and aesthetic concerns that would occupy him for almost four decades. It anticipates MacConnel's later works in its use of color, composition, pattern, flatness, overall coverage, disorientation, appropriation, art historical references, and vacillation between abstraction and representation.

The Picasso torso of the title appears as a horizontally striped red-and-white shape located in the upper right; MacConnel may have borrowed this form from a Picasso painting or self-portrait or from vintage photographs of the artist in a striped shirt. Although noted in the title, the Picasso torso carries no more weight in the visual experience of the work than any other random passage in the composition, and this is typical of MacConnel's democratic treatment of varied and disconnected imagery and geometric forms. It is this approach that the artist has explored repeatedly in the hundreds of paintings, drawings, and sculptures that he would eventually create following on that first small gouache.

Throughout his career MacConnel has continually referenced other masters of twentieth-century art, especially for their decorative elements, and he would draw inspiration from Picasso again several decades later. Modern artists, who frequently looked toward non-Western traditions for inspiration, included in their work African, Islamic, and Asian symbols and forms that they borrowed and transformed into new creations. MacConnel, like artists as diverse as Stuart Davis, Raoul Dufy, Henri Matisse, Joan Miró, and Robert Rauschenberg, reinterpreted differing approaches to form, color, pattern, and composition, and all of these artists share an appreciation and admiration of nontraditional art forms that blur the distinctions between "fine art" and "applied arts." As MacConnel has said: "What is impressive about decoration is that it goes on, in abundance, regardless of class, race, sex, country, or cultural center. Decoration is nearly everything."[1]

After his European sojourn MacConnel returned in 1973 to his studio in Encinitas, California, firmly dedicated to creating art. He began making drawings of carpet patterns as a way to understand their compositional system, and he became particularly intrigued by fabric pieces that were made of different ikat weaving patterns sewn together. During this period MacConnel drew from a wide range of art and decorative forms, including ethnographic rugs, ancient enameling, stenciled wallpapers, Persian kilims, and American craft traditions, gradually making paintings that mimicked the patterned textiles he admired. He discovered

that the best way to meld his many artistic, social, and cultural interests was by manipulating fabrics: these included primarily blank white cotton that he painted; found printed fabric upon which he applied paint; and unaltered commercially printed fabrics. He then used a sewing machine to combine various fragments into two-dimensional visual expressions that he attached to the wall with pins or tacks and which hung loosely and casually in the same manner as tapestries, weavings, and drapery.

This approach was in direct confrontation with the prevailing early-1970s attitudes that said that a contemporary work of art was painted on canvas (that had been layered with primer to obfuscate the cotton weave) stretched tightly over wooden bars to form a rigid square or rectangular shape. MacConnel further upended the tenets of contemporary art by including bright colors, decorative patterns, and recognizable subject matter, an approach rejected by prominent minimalist painters such as Brice Marden, Robert Mangold, and Agnes Martin.

MacConnel's earliest paintings—*Damask* and *Turkish Copy* (both 1973), *Turkistani Delight* (1974) (fig. 2) and *Texas Turkey* (1976)—all display his preoccupation with painting abstract patterns on cotton cloth using diluted acrylic paints. The resulting saturated colors soak into the fabric, showing blurry edges and intermingling colors (much like woven threads and yarns). These works recall the 1960s Color Field paintings of Helen Frankenthaler, Morris Louis, and Kenneth Noland which reveal the staining technique used in their making. These artists were championed by the art critics Clement Greenberg and Harold Rosenberg, who supported "advanced" abstract painting in the 1950s and 1960s. MacConnel was aware of their theories on modernity, but he modified their formalist concepts to fit his own need to insert subject matter and specific reference into his art.

MacConnel's *Damask* refers to the fabric with the same name: damask is a traditional reversible figured fabric with a pattern formed by the weaving process; the technique dates from the Byzantine and Islamic weaving centers of the Middle Ages and derives its name from the city of Damascus, Syria. This reference demonstrates MacConnel's interest in ancient and foreign cultures and his admiration of their respective cultural visual traditions and artistic expressions. In *Damask*, the artist reveals an updated version of an ancient technique. He began by painting a single sheet of fabric with an overall pattern of red, green, and brown curvilinear shapes on a yellow ground and then cut the fabric into random vertical strips. Ignoring the vertical and horizontal orientation of the original composition, he reorganized the pieces and sewed a number of them together, creating his first disorganized abstraction. *Texas Turkey* displays a related technique, but here the artist employed three different patterns with alternate positions that are cut and sewn into a single composition.

*Turkistani Delight* displays the artist's exploration of another historic weaving technique, the Indonesian ikat. Historically ikats have been symbols of status, wealth, power, and prestige; some cultures believe that the cloth is imbued with magical powers. In this style of weaving, a resist-dyeing technique (similar to tie-dye) is used on either the warp or weft to create a pattern or design before the threads are woven. Usually the pattern repeats in symmetrical or asymmetrical ways, but in MacConnel's version the tie-dyed thread procedure has been eliminated. The artist instead painted a diamond-shaped zigzag pattern of red lines and arranged them so that the left, center, and right panels of the composition are matched but the two interspersed panels are from a different composition.

It is in this painting that MacConnel's admiration of Henri Matisse is most apparent, with both artists evidencing a deep appreciation for patterned fabrics. Matisse grew up

fig. 2
Opposite, bottom: Kim MacConnel, *Turkistani Delight*, 1974
Acrylic on fabric, 78 x 66 inches
Collection of Julie Reyes Taubman and Bobby Taubman

fig. 3
Opposite, top: Henri Matisse, *Red Interior, Still Life on a Blue Table*, 1947
Oil on canvas, 45 ¾ x 35 inches
Kunstsammlung Nordrhein-Westfalen, Düsseldorf, Germany/©DACS/Les Heretiers Matisse/The Bridgeman Art Library

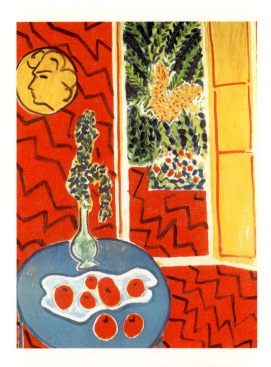

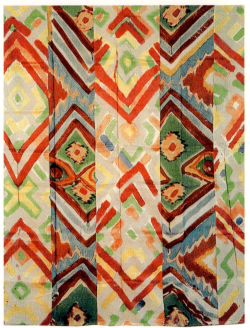

surrounded by fine French textile production in his hometown, Bohain-en-Vermandois, a center for highly regarded silks and taffetas. Matisse's *Red Interior, Still Life on a Blue Table* (1947) (fig. 3) is a superb example of the artist's use of a patterned black zigzag on a red-pink background to dominate the entire painting. Matisse has organized the interior composition into four vertical elements that depict a patterned wall, an open window with views out to palms and flowers in a garden, the window frame, and a sliver of wall at the far right; a blue table holding a flowered vase and red apples or tomatoes dominates the foreground. Matisse's erratic lines, similar to those used by MacConnel in *Turkistani Delight*, defy logic and establish an incomprehensible visual plane. It is also of interest to note that MacConnel has interspersed his geometric canvas with round floral motifs encased in diamond-shaped outlines just as Matisse splashed his canvas with palm fronds, flowers, and circular shapes in a similar manner.

MacConnel's next series of paintings became bolder in form and color and more complex in organization and composition. He also introduced into these works a new type of painted imagery that he borrowed from an inexpensive Chinese booklet illustrating lace patterns. This small publication offered the artist a wealth of visual information: it was a veritable encyclopedia of shapes and forms that already existed in the cultural landscape, ones that he could appropriate, colorize, alter, manipulate, and violate. *Tecate* (1974–75) displays an array of confusing, clashing lines and colors in vertical sections that are organized into a broad horizontal format of sweeping shapes. The painting, which is composed of fourteen sewn-together strips of fabric with uneven lengths at the bottom of the painting, includes six different lace patterns arranged into an asymmetrical sequence that can be read as numerical repeats (1-2-3-2-4-5-3-5-1-2-3-2-4-6).

*Red Lantern* (1975) also borrows imagery from lace patterns, but here they have become increasingly graphic and sometimes include representational imagery. The painting includes nine sections of nine different patterns; dominated by deep red, blue, and green colors, the patterns include sheaves of wheat crossed with rifles, a Buddhist-like wavy green and purple stripe, red and pink bars that reference Chinese funerary money, upside-down roses, ducks, and a colorful plaid. As MacConnel describes the painting, it is apparent that his working method and choice of subjects are convoluted: "*Red Lantern* is composed of strips of painting. I would paint these on bed sheets en masse without making any kind of differentiation of how they would be composed. I would paint until I had 200 or 300 of these strips. The imagery in it is a mix of things both decorative and specific. There's a Chinese decorated planter in one of the center panels, and below it are schematic sunflowers. Over on the left side of the piece, there's something that looks like peas in a pod which is actually a play off of Bizarre silk, which was a European weaving technique that was associated with Chinoiserie in the late Baroque and early eighteenth century in France, Italy, and in some degree, in Spain. I'm referencing it by painting it in a similar manner. Since Bizarre silk referenced not only the Near East but also China, to me it represented a kind of lineage between non-Western cultures in terms of trade routes or intellectual properties—which artists were at one time since they were traded between emperors and potentates depending on who won that war."[2]

*A Peal of Thunder in Days of Drought* (1976) also displays a combination of abstract lace patterns and imagistic forms. As the title suggests, it is a visual thunderstorm of colorful patterns crackling and cascading down vertical bands to puddle in uneven alignment at the floor. At the time MacConnel was having his first New York exhibitions at the Holly Solomon

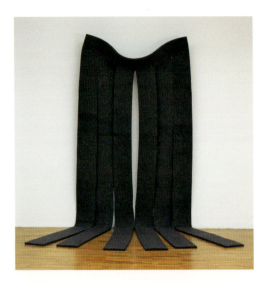

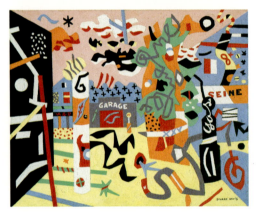

fig. 4
Top: Robert Morris, *Untitled*, 1969
Felt, 15 feet, ¾ inch x 6 feet, ½ inch x 1 inch
The Museum of Modern Art, New York;
The Gilman Foundation Fund

fig. 5
Opposite: Kim MacConnel, *Enjoy Five*, 1980
Gouache on painted paper collage,
48 x 87 inches
Courtesy of the artist

fig. 6
Bottom: Stuart Davis, *Report from Rockport*, 1940
Oil on canvas, 24 x 30 inches
Metropolitan Museum of Art, New York;
Edith and Milton Lowenthal Collection,
Bequest of Edith Abrahamson Lowenthal, 1991

Gallery, so the title might also suggest the artist's assessment of his own work in relationship to the current art scene in New York, which was governed by a minimal aesthetic.

In paintings completed in 1979, MacConnel revealed his interest in and reaction to minimal and postminimal artworks by such artists as Carl Andre, Donald Judd, Sol Lewitt, Robert Morris, and Richard Serra. MacConnel's paintings from this period are characterized by their tight horizontal format (reminiscent of clothes drying on a line), a more regularized rectangular shape of individual sections, and a physical alteration of materials, all of which mimic characteristics of the minimalists' attention to geometry, repetition, and found materials. He employed printed fabrics (found in local thrift shops) that he would then overpaint, rearrange, and perforate. Playful and engaging compositions, these works have goofy titles such as *Hot Pants Popper*, *Hula Popper*, *Meps Killer*, *Mister Twister*, and *Wob-L-Rite* (names all borrowed from commercial fishing lures).

Beneath this jocularity lies a serious reference to the work of Robert Morris (for example, *Untitled* [1969]) (fig. 4). MacConnel was familiar with and admired Morris's work from the 1960s, and he appreciated Morris's use and exploitation of commercial materials. Morris added a new dimension to the generally severe forms of minimalism by exploiting the plasticity of thick industrial felt. Similar to the way in which MacConnel has utilized strips of cut and punctured fabric, Morris made deep parallel cuts in the felt material and allowed it to drape unevenly and take whatever form the medium dictated. This method emphasizes the process of creation and the physical qualities of the material, and it incorporates elements of chance and randomness.

Although MacConnel recognized that he and Morris had similar impulses and paid similar attention to formal concerns, he was not content to leave the material unadulterated and undecorated as Morris had. *Hot Pants Popper* is composed of six different found fabrics organized in a quasi-symmetrical arrangement (similar to Morris's six strips of unaltered gray felt), but MacConnel blasts the viewer with garish contrasting patterns of color, shape, texture, and reflection. The artist cut into the body of the fabric scraps to create circles, squares, and ovals of negative space that reveal light and the wall behind the painting, adding a three-dimensional quality to the piece in the same manner that Morris's cut felt emphasizes the work's depth.

During the early 1980s MacConnel embarked on a delightful expedition to explore absurd imagery. His source material was *A Collection of Applied Designs*, a small stapled booklet of black-line drawings printed on thin newsprint pages and published in Hong Kong in the late 1960s. Like the lace pattern book from which he'd drawn earlier inspiration, this volume was found in a local used-book store, and it provided the artist with a cacophony of fascinating visual clichés: furniture, animals, telephones, *toreadors*, dancers, ballplayers, rickshaws, swimmers, hairdos, cigarette smokers, and airplanes. It was probably intended for commercial illustrators and advertising designers, but for MacConnel it was a mother lode of visual material to be translated into his paintings. Like the weavings, carpets, ikats, and lace patterns he had referred to previously, the generic designs and cartoons contained in this booklet offered visual information he did not have to newly create or interpret. He could commingle these drawings freely on a painted surface and adopt a style that was filtered through another vision, much like the eighteenth-century Chinoiserie he admired. As he cheerfully explains about his choice of subject matter: "I'm not making up anything."[3]

MacConnel began this group of works with a series of eight large-scale collages. Using a technique favored by Matisse in his cutouts of the 1940s and 1950s, he created these

collages with painted and cut paper. He selected a number of images from the applied design brochure, altered their scale and dimension, and then organized them into disconnected and irrational narratives. *Get Three* (1980), for example, depicts a woman in a black dress with a dog on a leash standing near a signpost and trash can which are arranged on a background of orange, white, and green. There is a black circle containing a jocular tennis-playing man painted in white outline; dancers and musicians are placed in front of an enlarged fragment of sheet music; a pipe is outlined in black on a green ground with orange smoke; and the enormous blue hand of a woman raising a martini glass in a toast is outlined by a pink square—and all of these are applied to a background of yellow and blue horizontal bands.

*Enjoy Five* (1980) (fig. 5), which shows six disparate images rendered in eleven colors, might be interpreted to suggest notions of entertainment and adventure—however, although MacConnel is aware of the inherent meaning of images, his primary objective is to create an exciting and energetic clash of visual stimulation. Stuart Davis displayed a related approach in the colorful paintings he created in the 1940s. With its lively network of flat, boldly colored shapes and graphics, *Report from Rockport* (1940) (fig. 6) represents Davis's signature style. Originally influenced by French cubism, he found great inspiration in the modern American landscape—the sometimes frenetic rhythms of jazz, the plethora of consumer products, and the fast pace of city life—and he wanted his paintings to express that energy. Like MacConnel, he experimented with color and space theories that postulate that color can be used to enhance spatial relationships. Davis's profusion of colors, lines, and patterns depicts gasoline pumps, garages, and storefronts, but the street scene is obscured: as in MacConnel's works, the result is an allover, disjointed surface suggesting movement and speed.

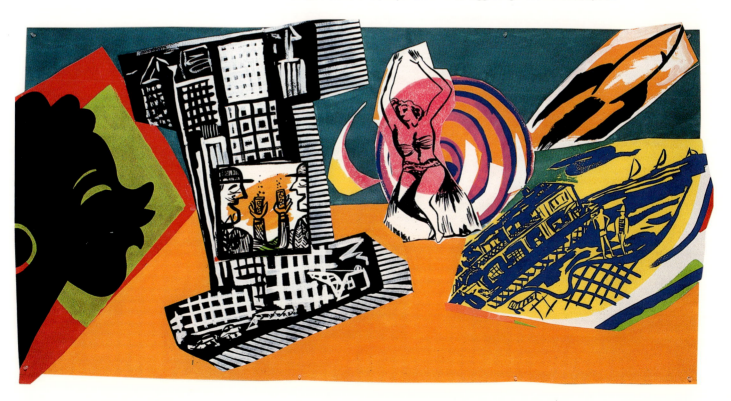

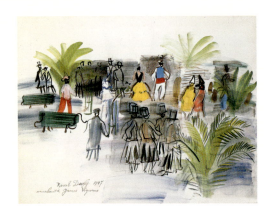

fig. 7
Top: Raoul Dufy, *Carnival in Perpignan*, 1947
Watercolor and gouache on paper,
19 1/2 x 25 1/2 inches
San Diego Museum of Art, Gift of Mr. and Mrs. Gerald Parker

fig. 8
Opposite: Sigmar Polke, *Kathereiner's Morning Wood (Kathreiners Morgenlatte)*, 1969–79
Acrylic, wood, mixed media, and framed collage on canvas and fabric,
7 feet, 6 9/16 inches x 10 feet, 2 1/16 inches
Guggenheim Museum, Bilbao

In his paintings from the early 1980s MacConnel continued to utilize odd and disorderly motifs mixed into a decorative format in order to express social, cultural, and political content: *Slideout* (1980) and *Nutritious* (1981) contain images of ice cream sticks, a ballplayer, a happy face, the Eiffel Tower, and bomb-laden missiles; these are combined with sewn strips of bright geometric, circular, and wavy patterns. He also created cartoon-style, three-dimensional versions of weapons in *Bomb* and *Missile* (1981), which are fashioned from stuffed paper and cardboard. These represent his ongoing effort to use decoration as a vehicle for examining important topics, including war, consumerism, exploitation, lethargy, and death. The artist elaborates: "What I was interested in when I called my work decorative was the irony. I was using a decorative vehicle while trying to carry content through the imagery, which I view as being nondecorative. And therein lies the irony."[4]

In *Formidable* (1981), MacConnel exhibits an inclination to express personal reactions to and assessments of things in the world around him. He utilizes his social, political, and religious beliefs in conjunction with carefully selected imagery to make a personal statement about the global situation. In discussing *Formidable*, the artist explains: "I put together chemistry bottles, men in top hats (sort of a cliché symbol for the 'capitalista'), and the hand, which is called 'Abhaya Mudra,' Shiva's right hand in his dance of the universe, which looks like he is signaling 'okay,' and it means that the universe is simply going where it's going regardless of what we do. That's the mixture of the spiritual, the symbolic, and the material—contradictions that correspond. This, to me, expresses some hope for the world."[5]

In 1983 MacConnel shifted from creating his work with painted and sewn lengths of fabric to using single bedsheets—specifically, California King–sized cotton sheets from Sears, Roebuck. He realized that he did not need to rely on individual strips of pattern and imagery in order to create disjunction and confrontation and could instead achieve a similar effect using a continuous surface. The paintings remained unstretched and loose on the wall and allowed him to include more subject matter and a wider range of colors. *Mop N' Glo* (1983), titled after the popular floor cleaner, retains some of the style of his vertical, sewn compositions as seen in the left panel (and looking remarkably like a Fernand Léger floral depiction), but it soon dissolves into a array of quasi-related subjects: the Eiffel Tower; the United States Capitol building; symbols for the U.S. dollar, Japanese yen, and British pound (this was painted before the introduction of the Euro); a mountainscape; Santa Claus; and a stylish woman in a hat. Although diverse, MacConnel's choice of imagery reflects how he selects subjects to comment on nationalism, monetary systems, and popular culture.

*Spectacular* (1984) and *Horsey Set* (1985) similarly present many disparate images— an ice skater, a modern-looking house, a sleeping nude, and a man on the phone, among others—thrown together randomly and with disregard to narrative continuity. The title *Horsey Set* (as well as its inclusion of a hat-wearing gentleman with a horse) could be a sly reference to the work of Raoul Dufy. As has become obvious, MacConnel is drawn to the tacky and corny in contemporary visual culture, a trait he admires in Dufy, who specialized in painting pretentious scenes of horse races (*Paddock at Deauville*, 1939), sailing events (*The Regattas at Deauville*, 1934), glamorous activities (*Casino at Nice*, 1950, and *Carnival in Perpignan*, 1947 [fig. 7]), and tourist attractions (*The Eiffel Tower*, 1935). MacConnel has painted many of these same scenes, and he shares with Dufy (as well as Picasso and Léger) a tendency to paint flat, linear, and abbreviated images that do not define or occupy three-

dimensional space and are located on broad, abstract areas of color that do not correspond to the subject matter or any specific locale. MacConnel relies on the powers of image and color to achieve an unbalanced yet still cohesive composition.

Even as he explored disarrayed subject matter further, in *Roman Landscape* (1986) MacConnel attempted to offer some focus to the subject. The painting, which uncharacteristically is on stretched canvas, depicts a rectilinear house with trees outlined in black against a green background and includes the sun in the sky (this is, presumably, as the title indicates, a Roman landscape); to the right is a circular shape that shows a Roman profile on a coin or sculptural relief; below is an extremely stylized red and green parrot in a cage; and to the left is a negative outline of a red fighter jet overlaid with a dark blue rectangle containing a graceful goose alighting on water. He then attached three found frames to the surface of the canvas in order to highlight and isolate specific visual information: he has framed a parrot already in a cage, segregated two images of airborne items, and defined a benign landscape. Framing these items may in fact be an ironic gesture because despite the fact that focus is placed on them, it still remains difficult to decipher the subjects.

The practice of attaching objects to a canvas is also frequently seen in Sigmar Polke's work, which shares many similar aesthetic concerns and visual language with MacConnel's. Polke was making quasi-pop paintings in the 1970s, although his concern (like MacConnel's) was with depicting objects from consumer society rather than the glorification of popular products. During the 1980s he used materials such as synthetic fabrics, silkscreens, lacquers,

and chemicals in order to undermine the conventions and media of painting. MacConnel was pursuing similar strategies, although he was unaware of Polke, whose work was not shown in New York until the early 1980s. (In fact, MacConnel had a number of European exhibitions during the late 1970s and was frequently asked if he was aware of the German artist's work because of the similarities between Polke's work and his own.)

Polke's *Kathereiner's Morning Wood (Kathereiner's Morgenlatte)* (1969–79) (fig. 8), is a layered composition of printed fabric and painted imagery depicting a schematic domestic interior superimposed over patterned fragments and written excerpts from mass media. Polke then literally deconstructed the painting by removing the stretcher bars and scattering the pieces across the surface, leaving only the top bar to suspend the loose and irregular painting from the wall. Like MacConnel, Polke enjoyed experimentation, abrupt stylistic changes and contradictions, irony, and humor, and he questioned the ability to sustain originality in contemporary art in the late twentieth century.

MacConnel continued to apply things—postcards, photographs, textured flocking—to the surface of his paintings in subsequent work, including *Indian Stars* (1986) and *Sri Ventakeshwara* (1987). These works resulted from the artist's frequent travels to places whose cultures inspire his art—in this case, India. To create *Indian Stars*, he prepared small stretched canvases and painted them with loose squiggly lines, circles, and geometric shapes in bright primary colors, and commercial postcards of Bollywood celebrities were then applied in a random fashion that mimicked the paint application. *Sri Ventakeshwara* has postcards attached that relate to MacConnel's visit to the most prominent Hindu site in India, Sri Venkateswara Temple, which is made completely of gold and ornamented with a magnificent crown. These paintings are embellished with cheap frames gaudily painted different colors on each side to cleverly announce their importance. He continued this practice on a grander scale in *Earth Day Sexy* (1995), which displays a loud, colorful, painted geometric background with enlarged photocopied images of a bathing beauty, a cute kitten, a Jean (Hans) Arp sculpture, a deflated balloon, other plastic debris, and a crumpled Lay's potato chip bag. The artist used all of these items in order to celebrate Earth Day and to reinforce what he describes as "connections that don't connect."[6]

MacConnel next turned to creating textured paintings, hoping to achieve the same type of rich surface and visual impact of the kitschy paintings on velvet that he admired on visits to Tijuana, paintings that usually depict Jesus, Elvis, clowns, or teary-eyed children. To achieve a similar effect, with acrylic on canvas he painted wild graphic diamonds, triangles, zigzags, circles, waves, grids, and sawtooth shapes reminiscent of Alexander Calder's abstract gouaches and Sister Mary Corita Kent's graphics of the 1960s. Although the edges of MacConnel's painted shapes became more controlled and defined than the smaller postcard paintings (such as *Indian Stars*), they retain a frenzied, dislocated position on the surface of the painting. To add to the visual disorder, the artist decided to add another layer of information by applying flocking (finely powdered synthetic fibers used to produce a velvety surface texture, as seen on flocked wallpaper). This required that he paint the painting twice: first to apply specific acrylic colors to a section of the canvas, and then in order to dust the colorless flock so that it would adhere to the wet paint. A time-consuming and mindless process, it had to be repeated for each portion of the canvas. MacConnel enjoyed the activity and admired the final result: an off-register alignment of the paint color and the unique texture. Fittingly, the paintings are titled after professional masked Mexican wrestlers who are known to appreciate endless abuse. *Máscara Cien Caras* and *Cara Dos Mil* (fig. 9) (both 1988) refer

fig. 9
Opposite, top: Kim MacConnel,
*Cara Dos Mil*, 1988
Acrylic on flocking and canvas,
90 x 90 ½ inches
Courtesy of the artist

fig. 10
Opposite, bottom: Robert Rauschenberg,
*Yoicks*, 1953
Oil, fabric, paper, and newsprint on two separately stretched canvases, 96 x 72 inches
Whitney Museum of American Art, New York;
Gift of the artist

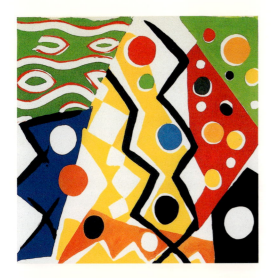

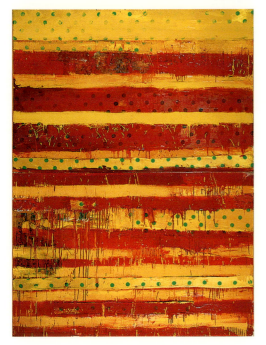

to Carmelo Reyes González, who is better known by his ring name "Hundred Faces," and his wrestling colleague "Máscara Año 2000" (often written as "Dos Mil").

The flocking greatly intensifies each color and visually suggests that the designs are printed on fabric, which enhances the overall effect of motion and weightlessness—it is as if they are zany flags or banners for a yet-to-be-established country. The colors, dots, and motion in these works recall *Yoicks* (fig. 10), a 1953 painting by Robert Rauschenberg, one of his most exuberant works and the first time he used fabric as a bold visual statement. After printed cloth with green polka dots on a yellow background was affixed to the canvas, Rauschenberg applied gestural horizontal bands of red and yellow paint. The repetitious bands of color, which dominate the graphic composition, recall Jasper Johns's "flag" paintings and Frank Stella's Black Paintings that were being created around the same time. The combination of the title—derived from a comic strip pasted to the surface—and the bold palette creates a celebratory mood that is also often apparent in MacConnel's lively paintings.

In the early 1990s MacConnel turned his attention to three-dimensional pieces, inspired by a two-month visit through West and sub-Saharan Africa in 1989 on a trip that he characterized as one "in search of Picasso's ghost." His aim was to research Picasso's use of West African tribal masks and artifacts as a subject for his developing interest in abstraction, as well as Picasso's (and other modernist artists') appropriation and transformation of elements from the core of tribal society into decorative components of modern art. The result was a group of sculptures that MacConnel called *Fetish Lamps* (1990). Vertical totems of disjointed found objects such as used paint cans, an electric fan, carved African figures, plastic toys, kitchen utensils, and decorative ceramic objects, these works all included some sort of electrical lighting.

The artist's interest in sculpture was further heightened by the 1993 Guggenheim Museum exhibition *Picasso and the Age of Iron*, which explored sculpture made in the years between the two world wars by Picasso, Alexander Calder, Julio González, and David Smith. He admired the imaginative and innovative ways that sculpture was constructed through an additive process of assembling and welding metals, and he was inspired to make a number of sculptures by utilizing a glue gun to assemble pieces of plastic found on the beach, resulting in *Beach Trash Clowns* (1994). These works express a delightful, inventive, and serious approach to object-making and display MacConnel's adept sense of composition, balance, and color. *Semafore* (1994) is a figure consisting of a white plastic bottle body (with colorful plastic buttons), black plastic head (with attached eyes and mouth), chef-like hat, and a jagged red arm shape supporting a string of yellow, blue, red, green, and orange scraps; the work acquired its title because the man seems to be using semaphore flags of different colors to convey coded information. In *Tipsy* (1994), MacConnel has created a figure who appears to be drunk: his head (a smashed white bowl with bottle-cap eyes and askew top hat) is leaning toward the right in a precarious posture; his red body seems to consist of parts of a broken beach chair; and his shoes are represented by a single red flipper. These types of three-dimensional figures are sometimes attached to a canvas with handmade metal brackets, as seen in *Flota* (1994), a bright orange background covered with large circles, and *Piggy* (1994), whose bold blue background is filled with colorful egg-shaped forms (borrowed from Andy Warhol's "Egg" paintings of 1982).

The similarities between MacConnel's clowns and Joan Miró's painted bronze sculptures created during the 1960s are striking. Made in the later part of his career (Miró was then in his seventies), these sculptures consisted of the junk he loved to assemble—commonplace

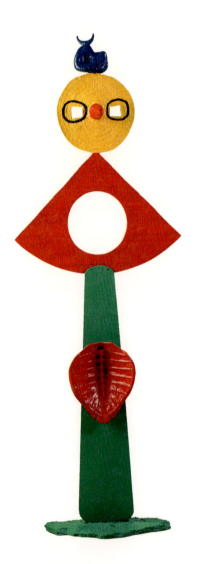

fig. 11
Joan Miró, *Caress of a Bird (La Caresse d'un oiseau)*, 1967
Painted bronze, 123 x 43½ x 19 inches
Raymond and Patsy Nasher Collection, Dallas, Texas

objects such as a pitchfork, faucet, chair, paint can lid, canister, and mannequin legs—and odd-shaped stones he would find on the beach. After arranging the objects on the floor without gluing them together, Miró would photograph them (often making notations and alterations on the picture) and then take the objects to the foundry to be cast into bronze—this was somewhat subversive since he always intended them to be painted in bright colors. At ten feet high, *Caress of a Bird (La Caresse d'un oiseau)* (1967) (fig. 11), is one of the artist's largest sculptures (excluding his monumental outdoor commissions) and among his most clever. Miró created a totemic figure of a woman whose yellow face was cast from a donkey's straw hat (the two holes for the animal's ears serve as her eyes) with a red bosom formed from a wooden farmhouse toilet seat, a green ironing board for her torso and legs, two soccer balls for buttocks, and a prominent red tortoise shell announcing the figure's gender. The work's title is derived from the blue bird perched on her head, cast from a stone to which Miró added horn-shaped wings made of clay. While MacConnel has cast one of his clowns in aluminum and added paint (*Clown*, 2005), it would be intriguing to see his beach-trash clowns standing twelve feet high in brilliant plastic-like colors.

At the beginning of the twenty-first century MacConnel decided to elaborate on the type of background painting he had created for the 1990s series with attached postcards and photographs. Maintaining the bright palette and geometric forms seen in those works, he enlarged and tightened the ovals, triangles, stripes, and diamonds into an overall composition of shape and color. These were painted on unstretched cotton sheets (each 102 by 108 inches), and because he restricted himself to just four different patterned designs per painting, these works have titles such as *4 Pattern Dub (#4)* and *4 Pattern Dub (#5)* (both 2004). These paintings are installed for exhibition with very little space between each sheet so that the overall effect is that of a gigantic, aggressive mural.

These works evolved into *Woman with Mirror*, one of MacConnel's most ambitious series of paintings (all 2007). As his title suggests, he is referring in these works to Picasso's renowned 1932 painting *Girl Before a Mirror* (fig. 12), one of the most iconic works in the collection of the Museum of Modern Art, New York. The painting depicts a young woman with blond hair and a round face (pink in profile and full-faced in yellow); she wears red rouge and lipstick, and her body is voluptuous, with full breasts and rounded stomach. She is all curves and circles and stripes. In the large oval shape of the mirror frame, a less lovely reflection (dark ovals surround her face and she has smaller, drooping breasts and a sagging belly) is on display. (This painting has been the subject of considerable analysis involving sexuality, mortality, pregnancy, male anatomy, and numerous Freudian interpretations). Most interesting in the context of MacConnel's interpretation of Picasso's work, there is little depth in the composition, and the background maintains an equal visual weight with the female subject. The diamond-patterned wallpaper recalls the costume of the Harlequin, the comic character from the Commedia dell'Arte with whom Picasso often identified himself. The painting presents a dazzling array of bright, clear colors, including red, yellow, blue, green, light green, pink, purple, orange, lavender, black, white, all with different variations.

MacConnel has remade Picasso's girl to his own liking—in fact, he has eliminated the literal description of a woman and her reflection completely, banishing any recognizable subject matter and thus abolishing any psychological associations. In addition, by using ordinary house paint (rather than acrylic) on wood panels, he has given the paintings a shiny, hard surface that enhances the color density and intensifies the junction between color shapes. MacConnel, who is not interested in the narrative of "girl before a mirror,"

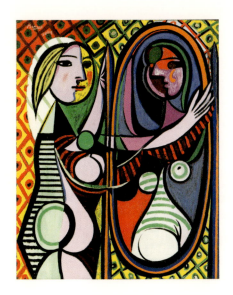

focuses instead only on the reductive identification of a *Woman with Mirror*. He has maintained the two prominent components of Picasso's painting—the figure and the mirror—but he has compressed the foreground and background into one single plane of form and color, acknowledging no depth, subject, or hierarchy of image. *Woman with Mirror, #1* depicts the figure as a stack of rectangles and triangles painted in black, blue, and white, while the mirror is represented as an upright disc shape with concentric rings of black, white, red, and yellow; surrounding these forms are areas of solid red and purple and striped sections of red and yellow and purple and white. *Woman with Mirror, #13* (fig. 13) presents five vertical sections of equal importance: horizontal bands of yellow and green; a bulbous vase or onion shape rendered in curves of black, green, and white; a pattern of red diamonds outlined in yellow (here MacConnel has reversed Picasso's use of yellow diamonds outlined in red); two blue triangles balanced on point and containing two white parallelograms; and alternating bands of orange and black. In another rendition, *Woman with Mirror, #9*, MacConnel has pushed the figure to the far left, almost off the canvas, and the center of the canvas is dominated by three angular zigzag shapes in red, green, and blue that offer a triple mirrored reflection balanced on the right with unusual vertical stripes in tan and white. This subject held strong interest for the artist, and he created almost thirty variations on the theme.

He continued working with geometric forms and bright colors, increasing the scale of the pieces dramatically. *Intermission* (2010) is a monumental 11-by-22-foot painting composed of 32 wood panels, each 33 inches square. The panels are joined and painted over as a single

fig. 12
Top: Pablo Picasso, *Girl Before a Mirror*, 1931
Oil on canvas, 64 x 51½ inches
The Museum of Modern Art, New York;
Gift of Mrs. Simon Guggenheim

fig. 13
Bottom: Kim MacConnel, *Woman with Mirror, #13*, 2007
Latex acrylic on canvas, 48 x 48 inches
Courtesy of Glenn Schaeffer

surface, but their manageable size allows the artist to expand the painting size exponentially. He switched to the use of gloss enamel paint that, on this scale, gives the painting the crisp look of glazed tiles or aluminum panels. Although the sweeping curves, sharp angles, and clean lines of the shapes suggest an Ellsworth Kelly painting gone out of control, MacConnel is firmly in control here. There are more than ten segments, and the artist has orchestrated each form and each color as if they were elements of a visual symphony.

MacConnel has created a formidable body of work during the forty years of his career, and he has maintained an honest and clear artistic trajectory that is as consistent as it is surprising. In the artist's words: "There is a thread that runs through it all. It's about really looking at the informal, at the decorative, at casually made work, and home craft like quilting. I'm looking at the idea of the other, the outcast, in terms of society and contemporary art. I've been interested in that edge between what's acceptable and not acceptable within the canons of art making. I keep looking at that edge."[7]

Kim MacConnel has introduced a unique visual vocabulary that absorbed, digested, responded to, and borrowed from the canons of modern art history and the prevalent minimal and postminimal aesthetics of the 1960s and 1970s art world. MacConnel is one of the generation of artists who introduced inventive format, radical composition, and unexpected imagery during the late seventies: he and artistic colleagues such as Martin Kippenberger, Barbara Kruger, Robert Kushner, Richard Prince, Susan Rothenberg, David Salle, and Philip Taaffe redefined the then commonly held precepts of contemporary art. Having grasped the methodology of Pop art and rejecting the rigid confines of minimal art, MacConnel injected his art with subjective content, appropriated imagery, and expressionistic brushwork. Employing often maligned forms of pattern and decoration, he infused his art with a renewed sense of urgency and timeliness. He introduced new materials, unique techniques, and unusual subjects that questioned the existing canons of what a work of art can be even as he simultaneously acknowledged his predecessors and built upon their contributions. Kim MacConnel has forged a new and imaginative aesthetic that liberates contemporary artistic expression. His is a new visual language for a contemporary voice.

---

1. Kim MacConnel, interview with the author, May 12, 2010.

2. Kim MacConnel quoted in "Kim MacConnel: Carrying Content Through the Decorative, Therein Lies the Irony," in Michael Duncan and Lisa Melandri, eds., *Parrot Talk: A Retrospective of Works by Kim MacConnel* (Santa Monica, Calif.: Santa Monica Museum of Art, 2003), p. 5. The transcript is of a filmed inteview of MacConnel by Seonaid McArthur (co-produced by UCSD-TV and Museum of Contemporary Art San Diego; Lynn Burnstan and Hugh Davies, executive producers).

3. Kim MacConnel quoted in Richard Armstrong, *Collection Applied Design: Kim MacConnel* (La Jolla, Calif.: La Jolla Museum of Contemporary Art, 1976).

4. MacConnel, "Kim MacConnel: Carrying Content Through the Decorative, Therein Lies the Irony," p. 5.

5. Kim MacConnel quoted in Robert Becker, "Kim MacConnel," originally published in *Interview* 12 (June 1982). In Richard Marshall, *American Art Since 1970: Painting, Sculpture, and Drawings from the Collection of the Whitney Museum of American Art, New York* (New York: Whitney Museum of American Art, 1984), p. 78.

6. Kim MacConnel, interview with the author, May 10, 2010.

7. Kim MacConnel, quoted in Leah Ollman, "Kim MacConnel," *San Diego Home/Garden Lifestyles* (January 2009), p. 83.

Works by Kim MacConnel

*Damask*, 1973
Acrylic on fabric, 48 x 30 inches
Courtesy of the artist

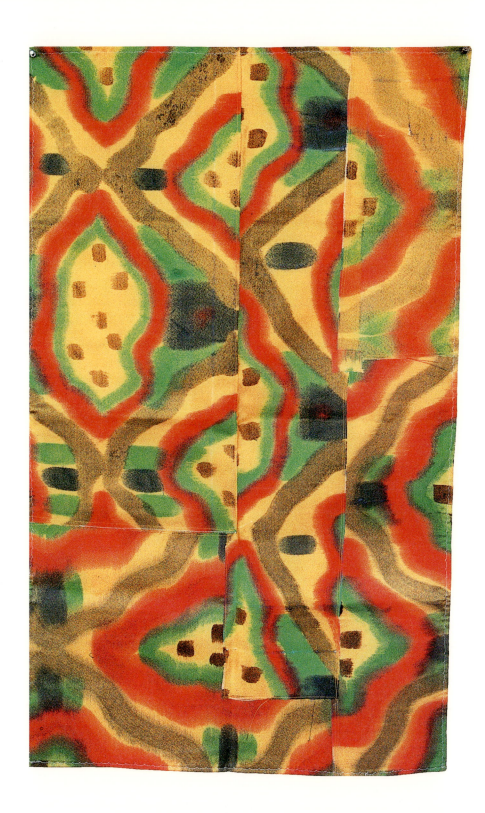

*Ten Items or Less*, 1975
Gouache on paper, 15 ½ x 21 inches
Courtesy of the artist

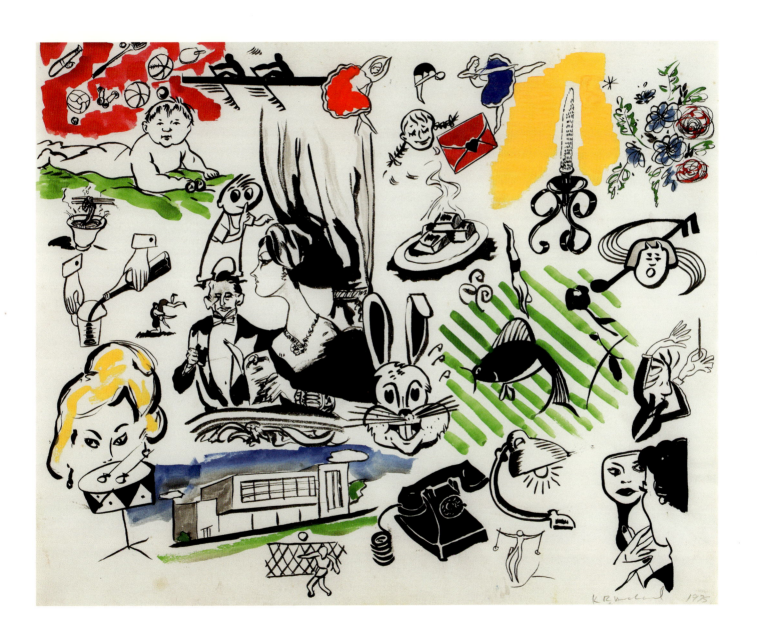

*A Peal of Thunder in Days of Drought*, 1976
Acrylic on fabric, 90 x 75 inches
Courtesy of the artist

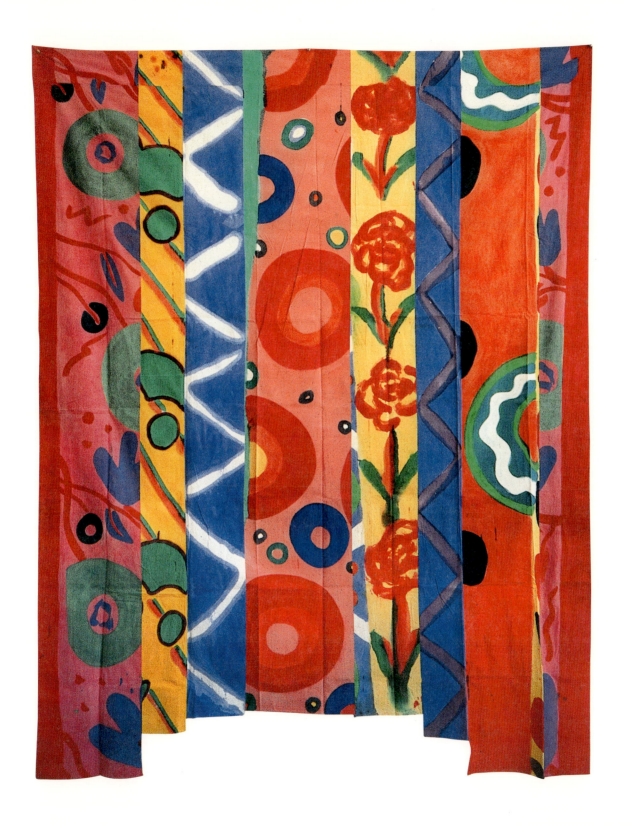

*Bamboo Curtain*, 1978
Printed fabric curtain and bamboo, 104 x 65 inches
Courtesy of the artist
(not in exhibition, from the series *Bamboo Curtain*)

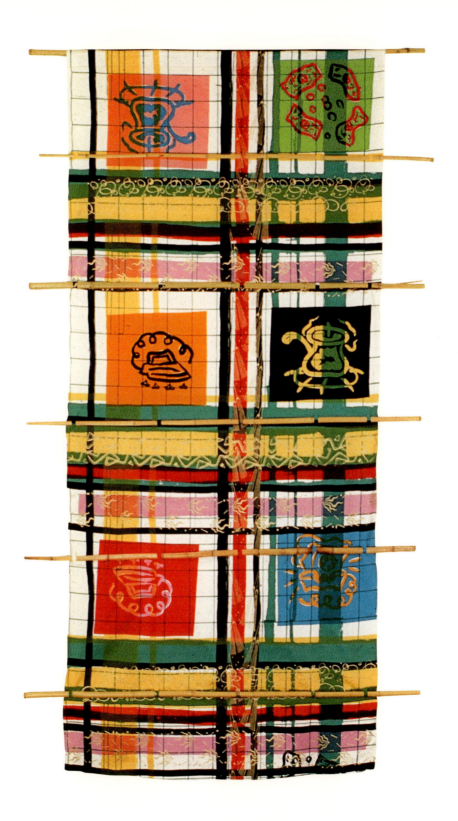

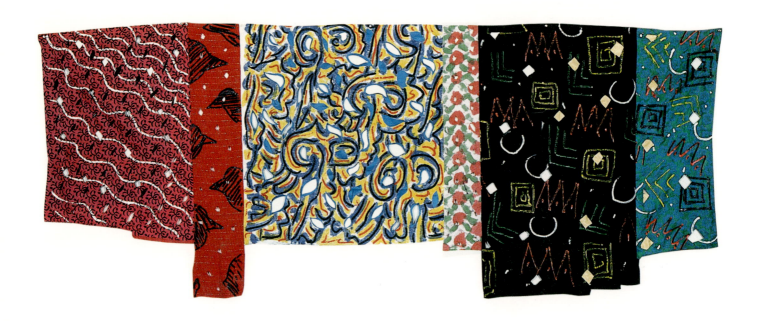

*Hot Pants Popper*, 1979
Acrylic on fabric, 44 x 109 inches
Courtesy of the artist

*Good Work*, 1979
Acrylic on fabric, 50 ½ x 114 inches
Marieluise Hessel Collection, Hessel Museum of Art, Center for Curatorial Studies, Bard College, Annandale-on-Hudson, New York

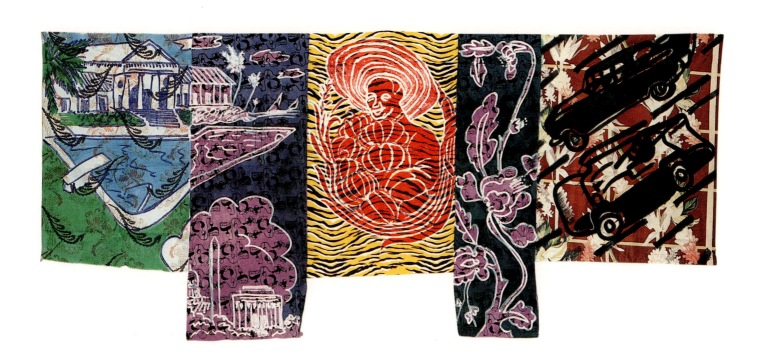

*Goalie*, 1980
Gouache on paper, 13 x 19 ½ inches
Collection of Erika and Fred Torri

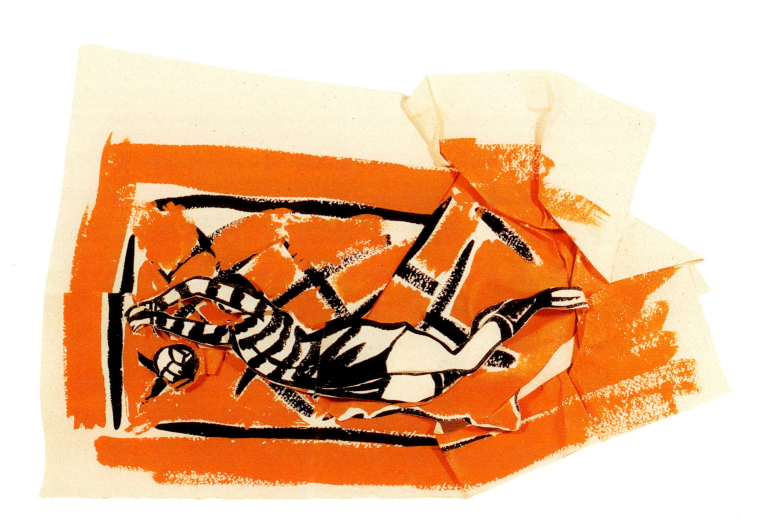

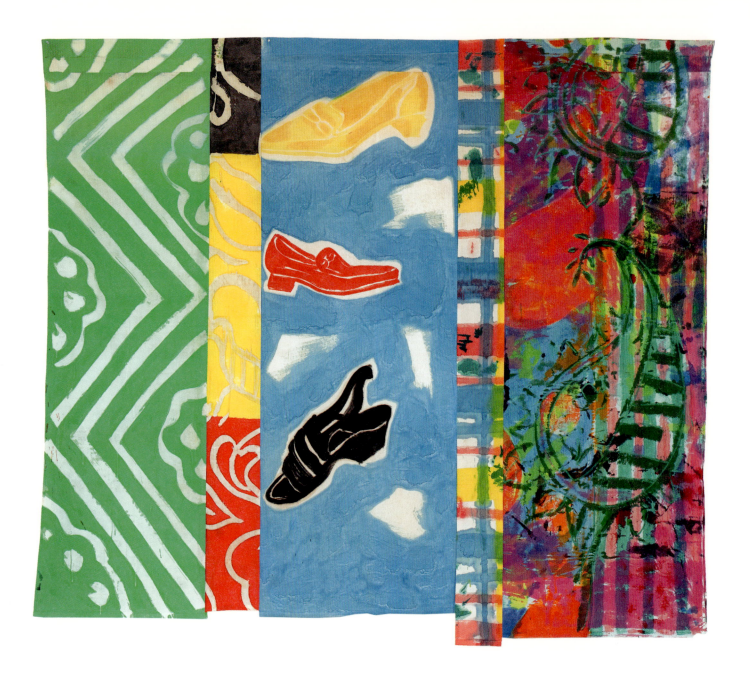

*Shoesettes,* 1980
Acrylic on fabric, 96 x 108 inches
Collection of Nina MacConnel and Tom Chino

*Nutritious,* 1981
Acrylic on fabric, 93 x 130 inches
Courtesy of the artist

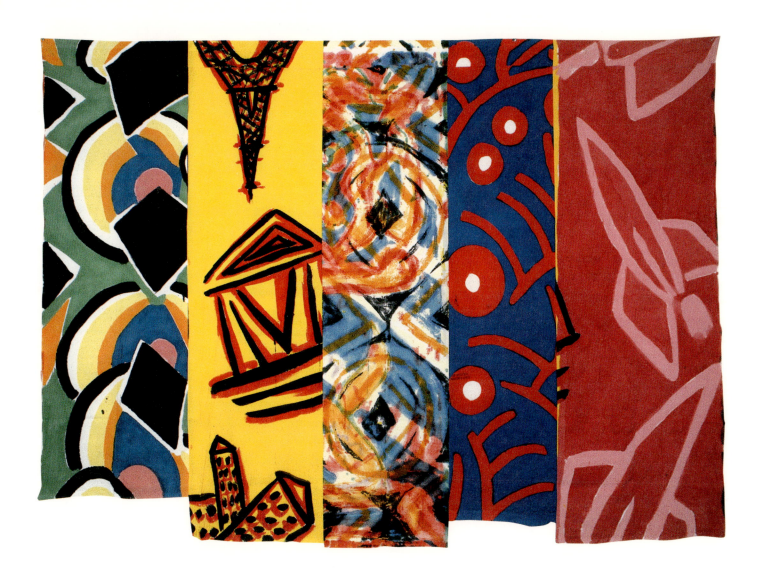

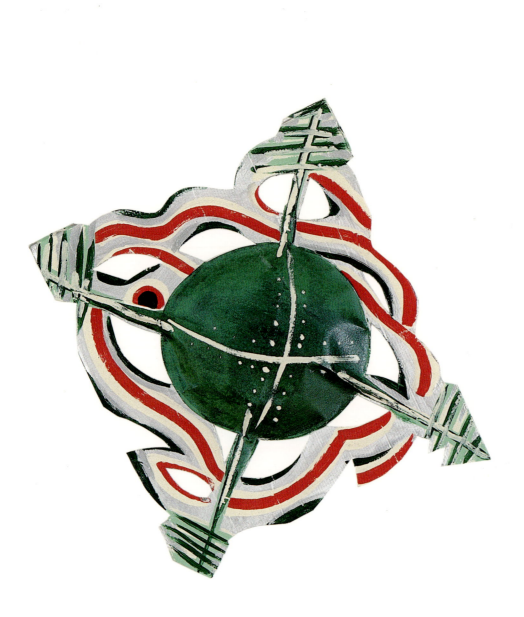

*Satellite*, 1981
Painted cardboard, 37 ½ x 32 x 2 ½ inches
Courtesy of the artist

*Missile*, 1981
Painted cardboard, 69 x 37 ½ x 2 ½ inches
Courtesy of the artist

*Bomb*, 1981
Painted cardboard, 33 ½ x 32 ¼ x 2 ¾ inches
Courtesy of the artist

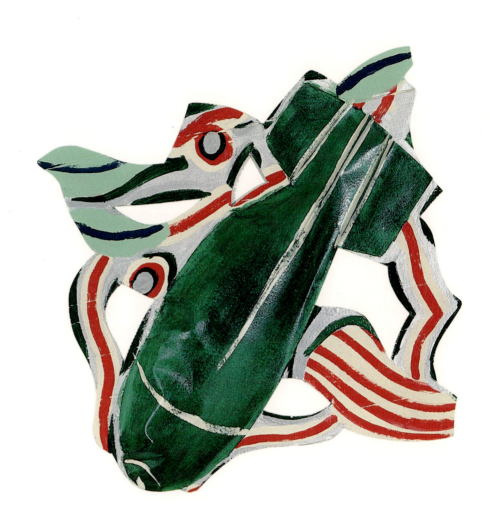

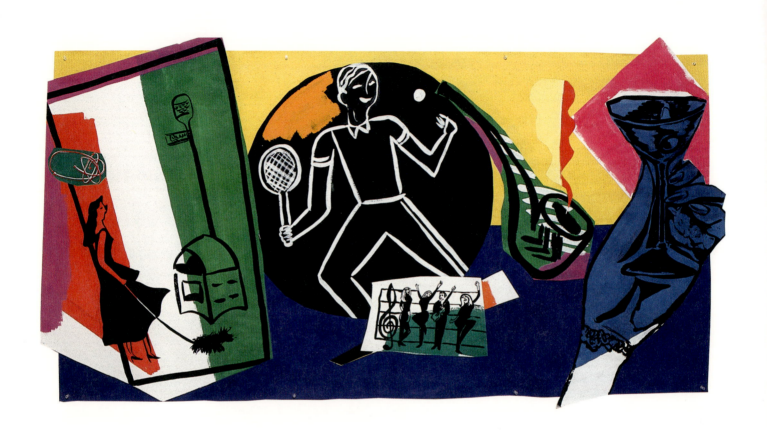

*Get Three*, 1982
Gouache on paper collage, 43 1/2 x 82 inches
Courtesy of the artist (not in exhibition)

*Ad Jile*, 1980
Gouache on painted paper collage,
37 1/2 x 57 inches
Courtesy of the artist

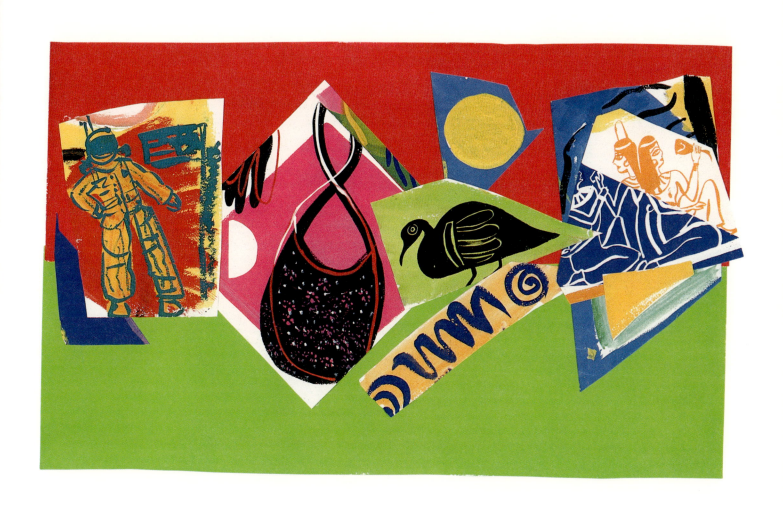

Mop N' Glo, 1983
Acrylic on fabric, 96 x 108 inches
Albright-Knox Art Gallery, New York, Gift of Seymour H. Knox Jr., 1983 (not in exhibition)

Spectacular, 1984
Acrylic on fabric, 97 x 110 inches
Marieluise Hessel Collection, Hessel Museum of Art, Center for Curatorial Studies, Bard College, Annandale-on-Hudson, New York
(not in exhibition)

*Sri Ventakeshwara*, 1987
Acrylic and postcards on canvas, framed,
18½ x 22½ inches
Courtesy of the artist

*Hula Girl*, 1986
Acrylic on canvas with painted frame,
32 x 26 inches
Collection of John and Thomas Solomon

*Roman Landscape*, 1986
Acrylic on canvas with found frames,
56 x 73 x 5 inches
Courtesy of the artist

*Máscara Cien Caras*, 1988
Acrylic and flocking on canvas, 90 x 138 inches
Collection of Ellen and Jimmy Isenson

*Flota*, 1994
Assembled found objects, metal stand, and
acrylic on canvas, 78 x 48 inches
Courtesy of the artist

*Earth Day Sexy*, 1995
Acrylic, photocopies, and objects on canvas,
96 x 115 inches
Courtesy of the artist

*Woman with Mirror, #12*, 2007
Latex acrylic on canvas, 48 x 48 inches
Courtesy of the artist and Rosamund Felsen
Gallery, Santa Monica

*Woman with Mirror, #7*, 2007
Latex acrylic on canvas, 48 x 48 inches
Collection of Charles Reilly and Mary Beebe

*Woman with Mirror, #9*, 2007
Latex acrylic on canvas, 48 x 48 inches
Collection of Leon and Sofia Kassel

*Woman with Mirror, #14*, 2007
Latex acrylic on canvas, 48 x 48 inches
Courtesy of the artist and Rosamund Felsen
Gallery, Santa Monica

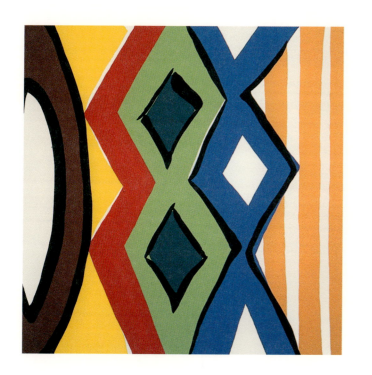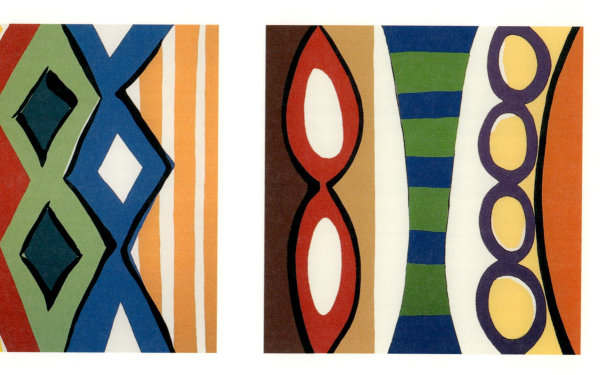

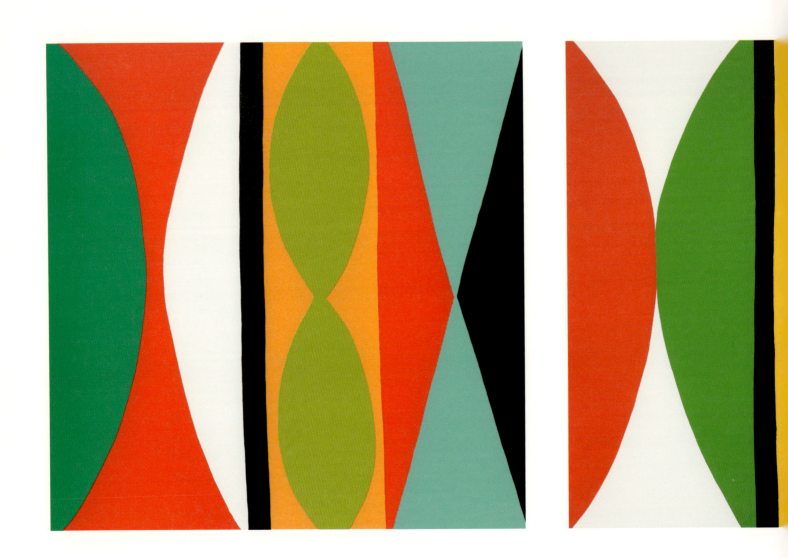

*E123*, 2010
Enamel on panel, triptych: 46 x 46 inches each
Museum of Contemporary Art San Diego,
Museum Purchase, International and
Contemporary Collectors Funds

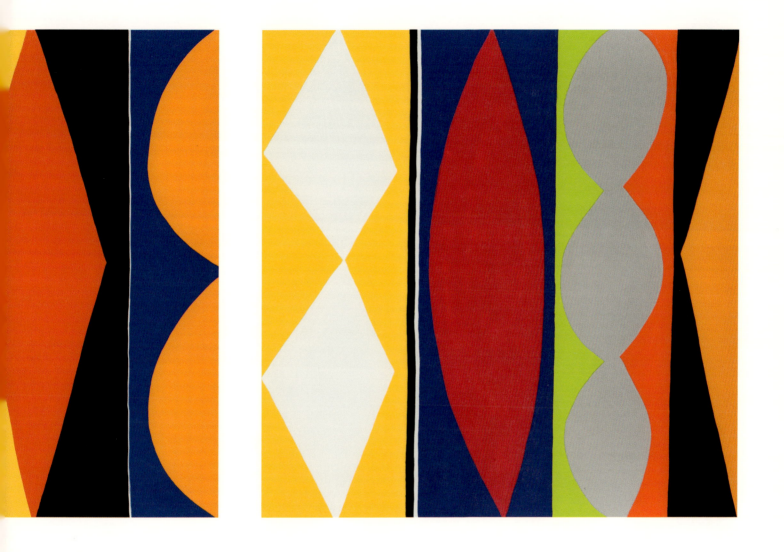

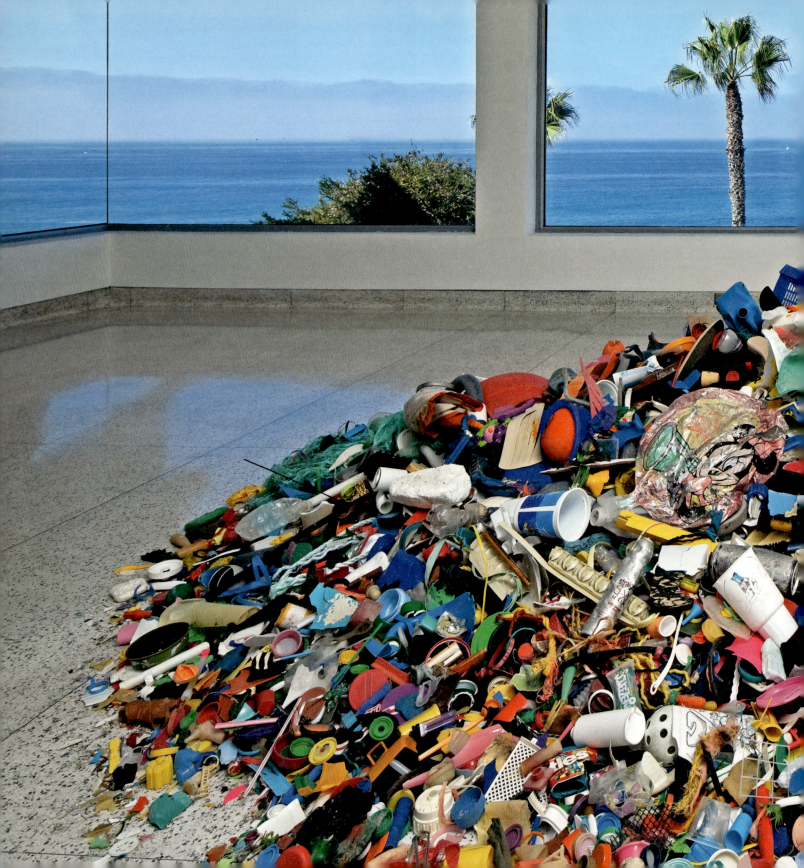

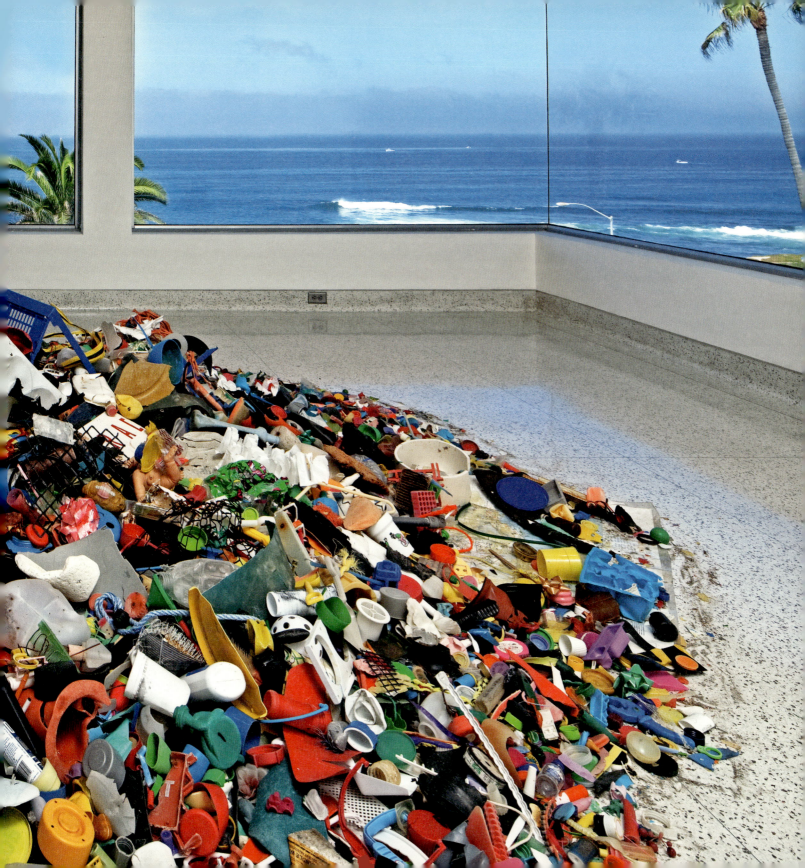

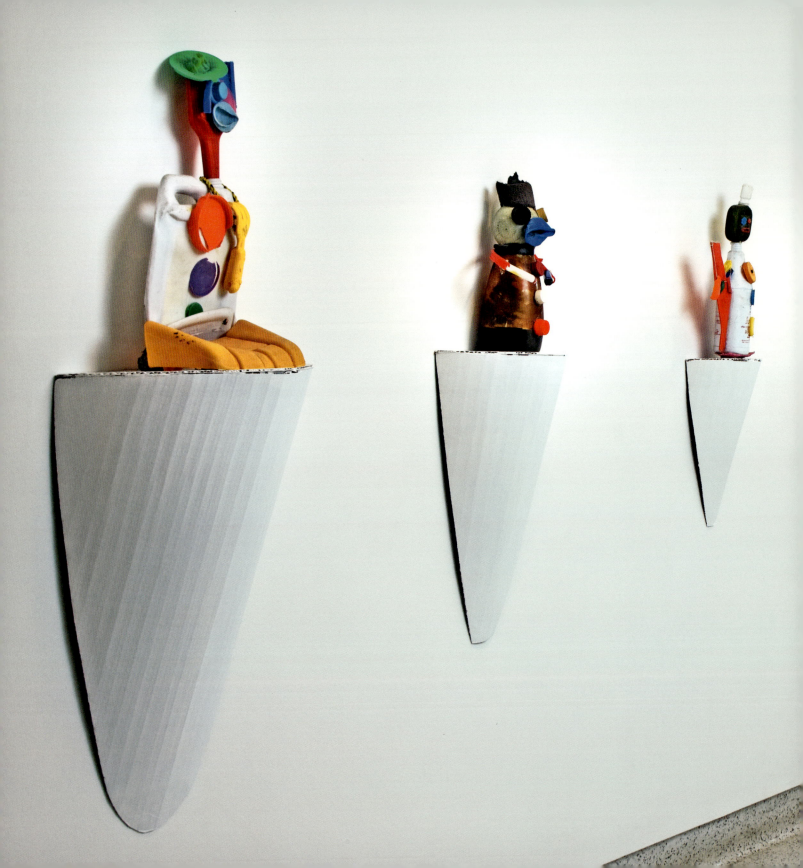

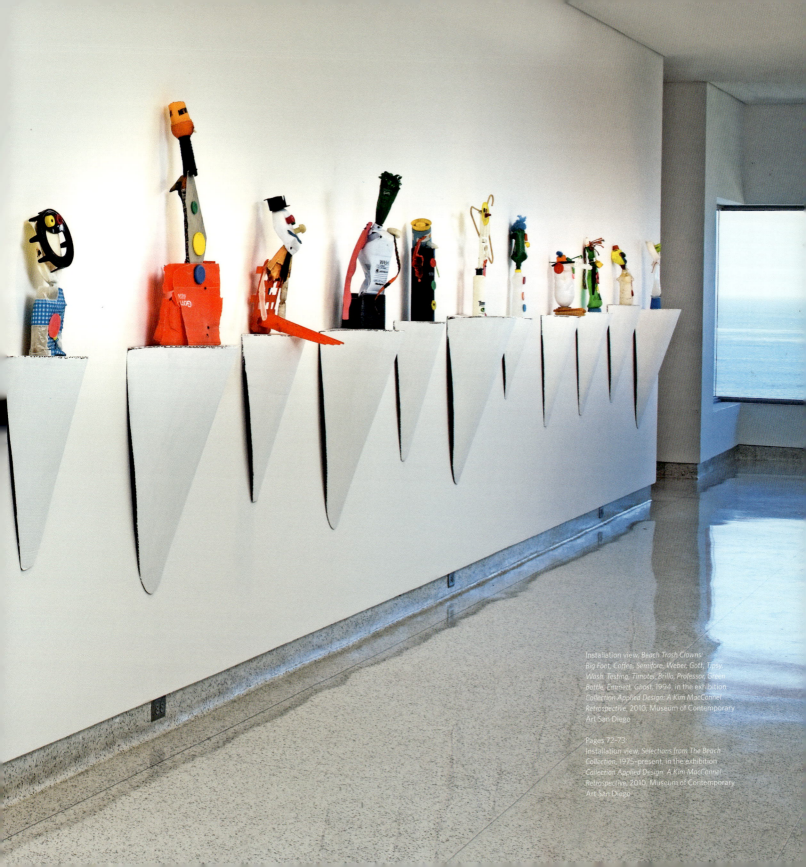

Installation view, *Beach Trash Clowns: Big Foot, Coffee, Semifore, Weber, Gott, Tipsy Wash, Testing, Timotei, Brillo, Professor, Green Bottle, Emmett, Ghost*, 1994, in the exhibition *Collection Applied Design: A Kim MacConnel Retrospective*, 2010, Museum of Contemporary Art San Diego

Pages 72–73
Installation view, *Selections from The Beach Collection*, 1975–present, in the exhibition *Collection Applied Design: A Kim MacConnel Retrospective*, 2010, Museum of Contemporary Art San Diego

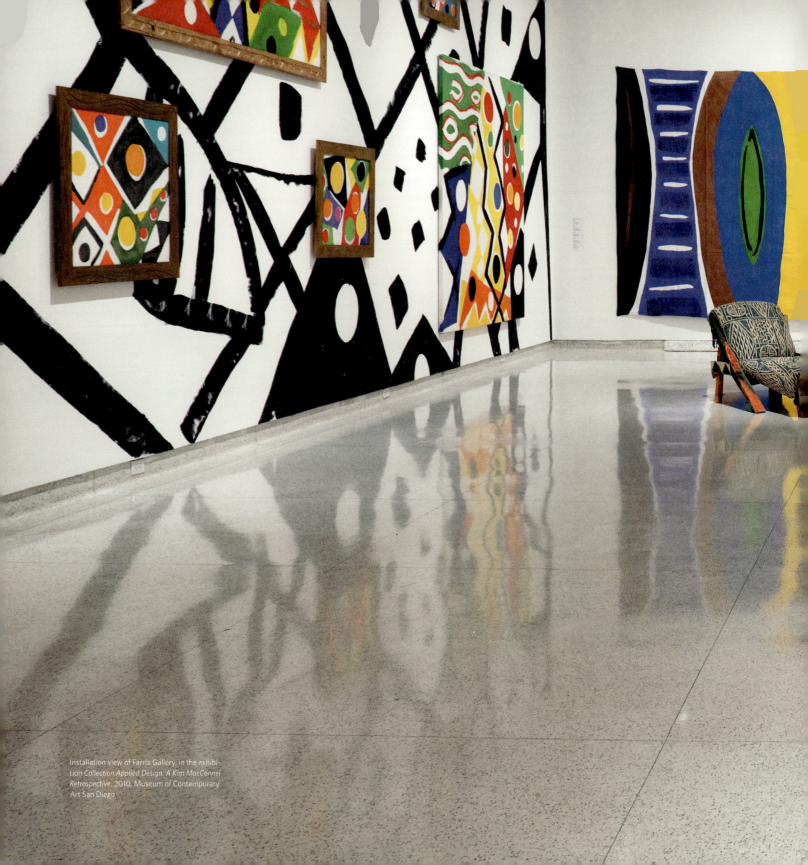

Installation view of Farris Gallery, in the exhibition *Collection Applied Design: A Kim MacConnel Retrospective*, 2010, Museum of Contemporary Art San Diego

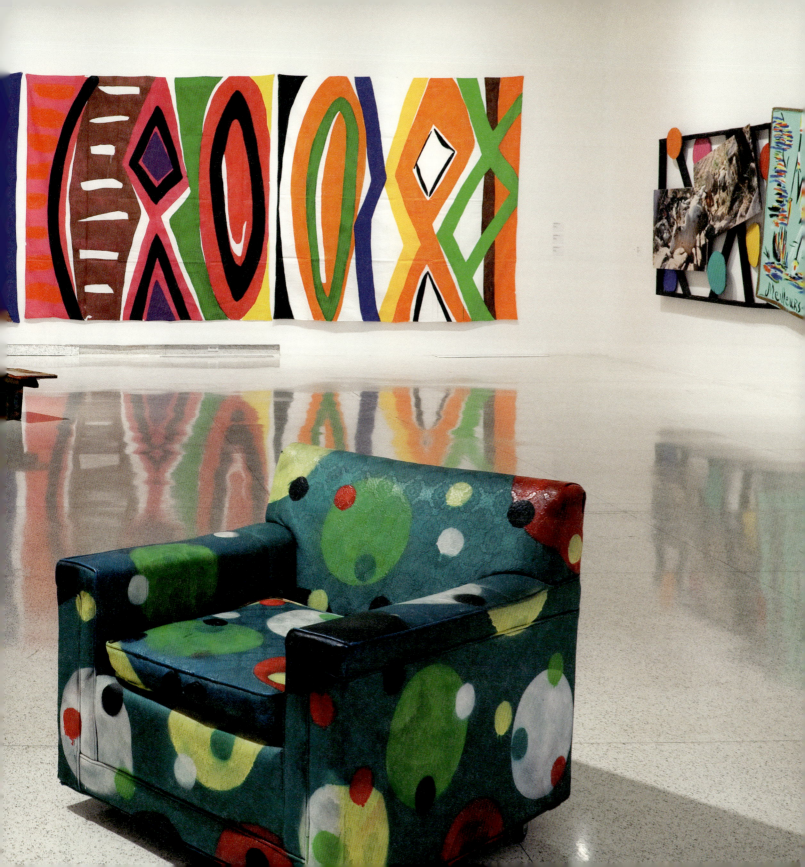

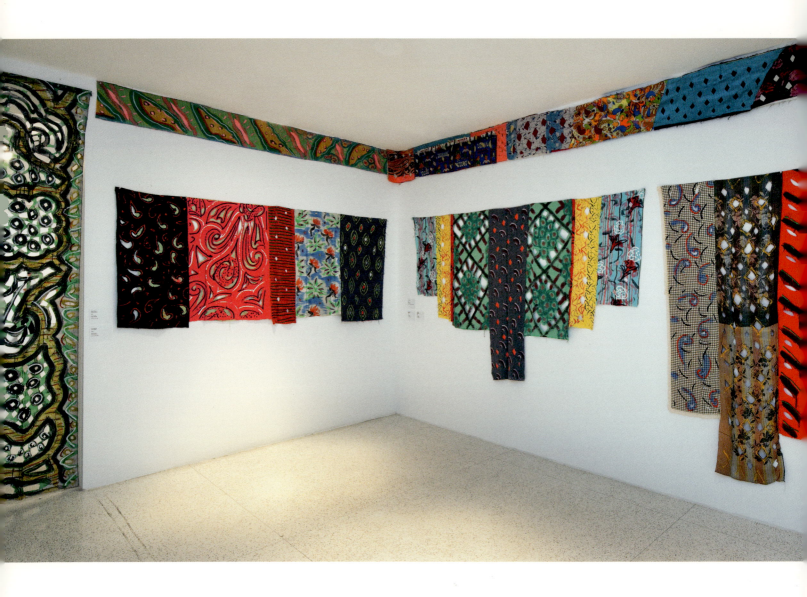

Installation view and detail (right) of fabric works, circa 1979, in the exhibition *Collection Applied Design: A Kim MacConnel Retrospective*, 2010, Museum of Contemporary Art San Diego

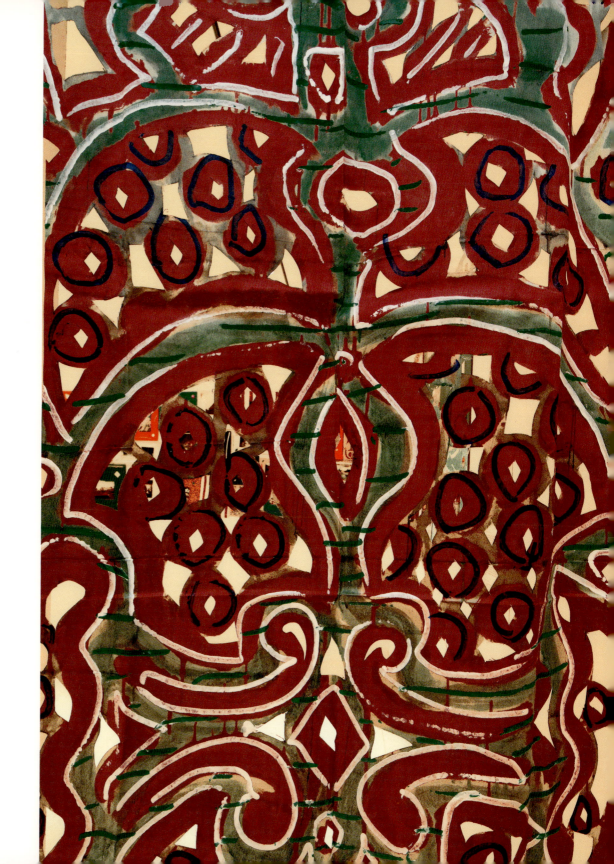

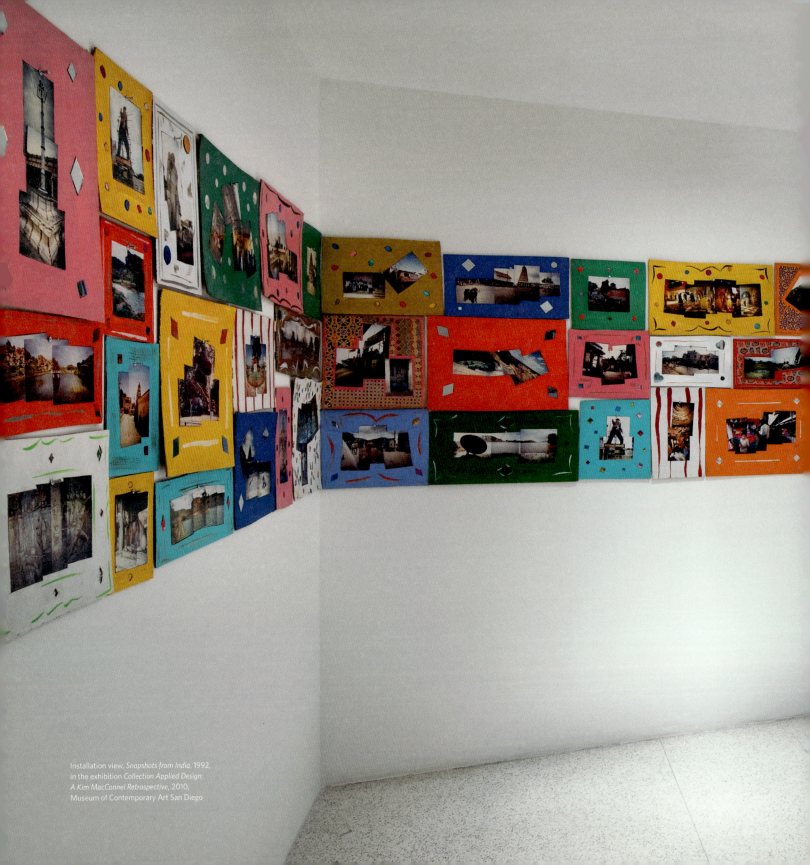

Installation view, *Snapshots from India*, 1992, in the exhibition *Collection Applied Design: A Kim MacConnel Retrospective*, 2010, Museum of Contemporary Art San Diego

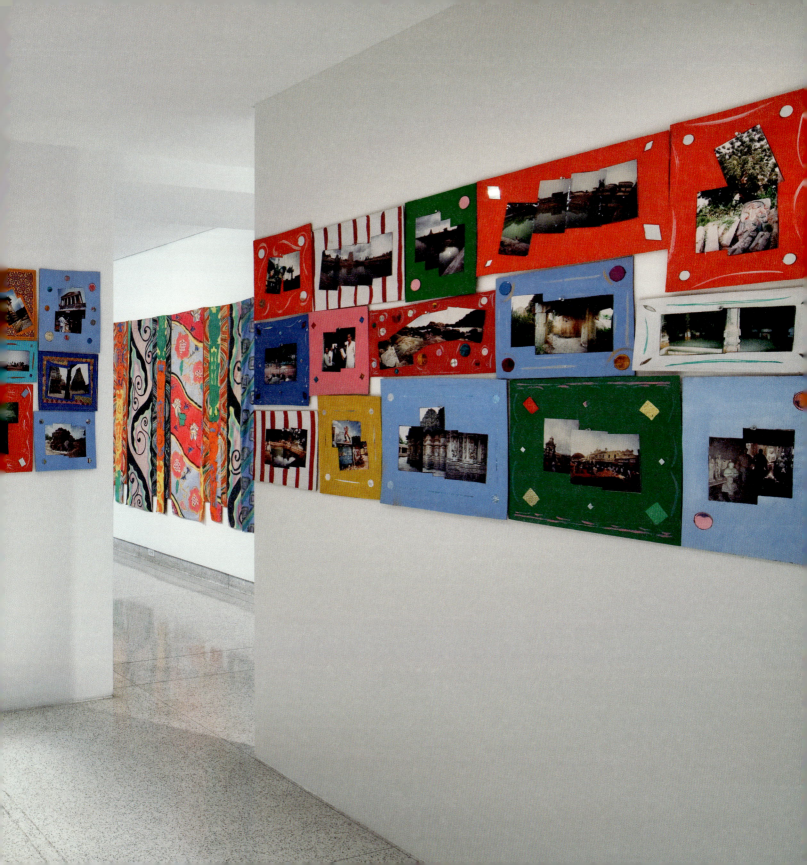

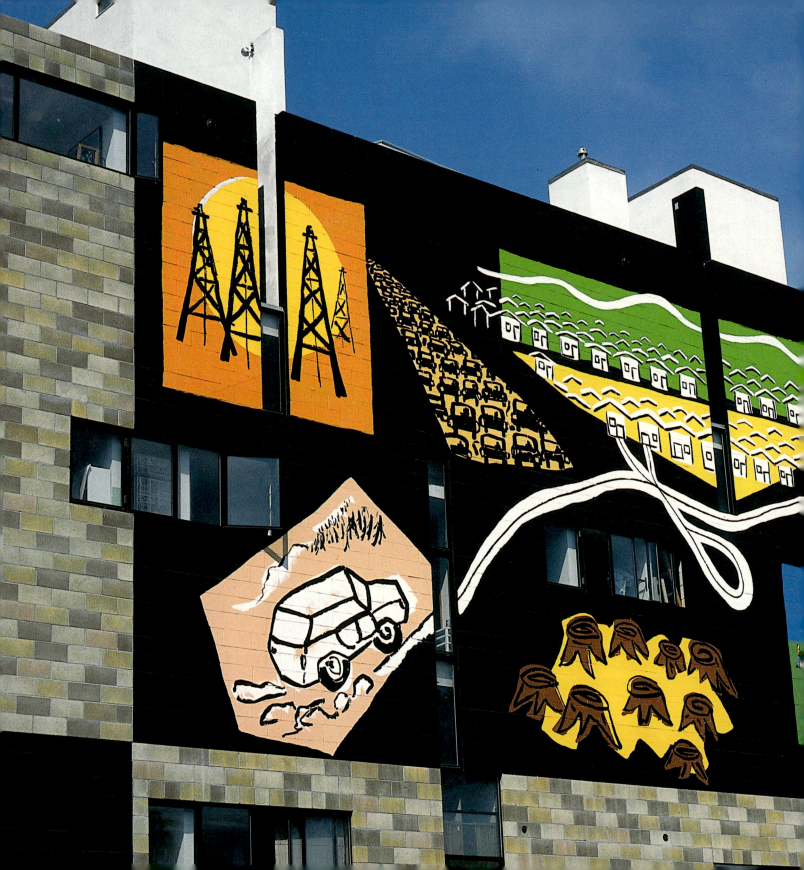

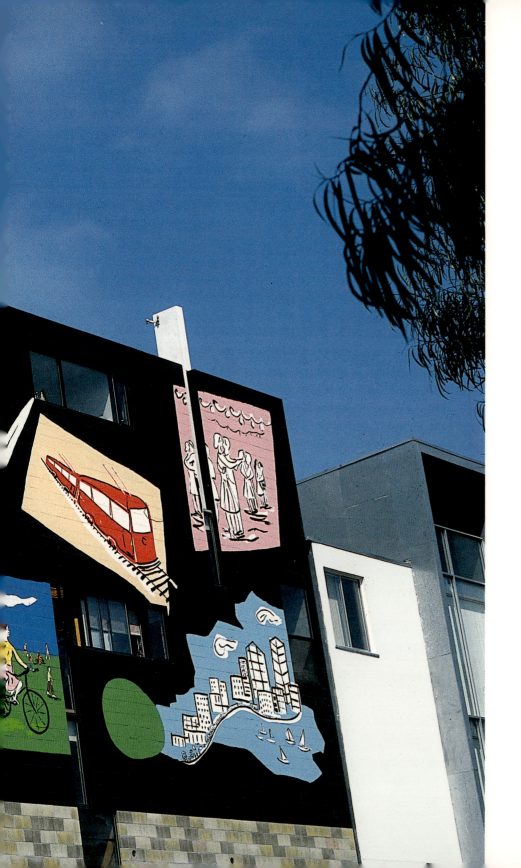

*Reverse Commute*, 2003
Latex acrylic on concrete, approx. 50 x 150 feet
Private building in San Diego
Courtesy of the artist and Ted Smith and Others Architectural Firm

*Girl from Ipanema*, 2010
Enamel paint on concrete, 45 x 20 x 9 feet
Private building in La Jolla
Courtesy The La Jolla Community Foundation
and Quint Contemporary Art

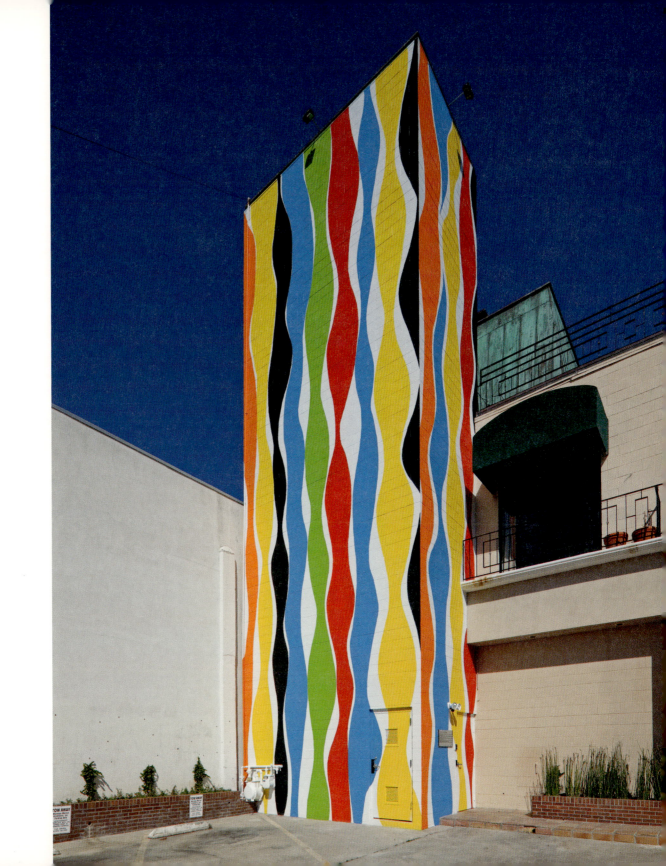

## EXHIBITION CHECKLIST

As of September 28, 2010

*Butter*, 1973
Gouache on paper
14¾ x 18½ inches
Courtesy of the artist

*Damask*, 1973
Acrylic on fabric
48 x 30 inches
Courtesy of the artist

*Untitled*, 1973
Gouache on paper
13¾ x 17 inches
Collection of Sue K. and
Charles C. Edwards

*Scrim*, 1974
Acrylic on fabric
60 x 65 inches
Courtesy of the artist

*Turkistani Delight*, 1974
Acrylic on fabric
78 x 66 inches
Collection of Julie Reyes Taubman and
Bobby Taubman

*Tecate*, 1974–75
Acrylic on fabric
78 x 108 inches
Courtesy of Roy and Gail Kardon

*Collection Applied Design*, 1975
Acrylic on fabric
79¾ x 70 inches
Collection of John and
Thomas Solomon

*Red Lantern*, 1975
Acrylic on fabric
84 x 108 inches
Museum of Contemporary Art
San Diego, Museum Purchase

*Selections from The Beach Collection*,
1975–present
Beach trash
Dimensions variable
Courtesy of the artist

*Ten Items or Less*, 1975
Gouache on paper
15½ x 21 inches
Courtesy of the artist

*Untitled*, 1975
Gouache on paper
13¾ x 17 inches
Courtesy of the artist

*Glitter*, 1976
Acrylic and glitter on fabric
45 x 70 inches
Courtesy of the artist

*A Peal of Thunder in Days of Drought*,
1976
Acrylic on fabric
90 x 75 inches
Courtesy of the artist

*Texas Turkey*, 1976
Acrylic on fabric
74½ x 37½ inches
Courtesy of the artist

*Turquoise Settee*, 1976
Painted furniture
25 x 30 x 70 inches
Courtesy of the artist

*Bamboo Curtain*, 1978
Printed fabric curtain and bamboo
104 x 65 inches
Courtesy of the artist

*Lotus*, 1978
Painted cardboard
33 x 25 inches
Courtesy of the artist

*Louisville*, 1978
Acrylic on fabric
95 x 119½ inches
Collection of Marcia and Irwin Schloss

*Progress*, 1978
Fabric and bamboo
127 x 66 inches
Collection of Bruno Bischofberger,
Zurich

*Spare Time Shooting Practice*, 1978
Mixed fabrics
124 x 145½ inches
Collection of Bruno Bischofberger,
Zurich

*Vase*, 1978
Painted cardboard
31 x 20 inches
Courtesy of the artist

*Fat Ray*, 1979
Acrylic on fabric
49 x 56 inches
Collection of John and
Thomas Solomon

*Good Work*, 1979
Acrylic on fabric
50¼ x 114 inches
Marieluise Hessel Collection,
Hessel Museum of Art, Center for
Curatorial Studies, Bard College,
Annandale-on-Hudson, New York

*Hot Pants Popper*, 1979
Acrylic on fabric
44 x 109 inches
Courtesy of the artist

*Hula Popper*, 1979
Acrylic on fabric
41 x 93 inches
Courtesy of the artist

*Jitterbug*, 1979
Acrylic on fabric
120 x 48 inches
Courtesy of the artist

*Little Cleo*, 1979
Acrylic on fabric
72 x 56 inches
Courtesy of the artist

*Meps Killer*, 1979
Acrylic on fabric
58 x 100 inches
Courtesy of the artist

*Mirro Lure*, 1979
Acrylic on fabric
120 x 48 inches
Courtesy of the artist

*River Shiner*, 1979
Acrylic on fabric
10 x 183 inches
Courtesy of the artist

*Rooster Tail*, 1979
Acrylic on fabric
17 x 444 inches
Courtesy of the artist

*Sidewinder*, 1979
Acrylic on fabric
13½ x 168 inches
Collection of David Diamond and
Karen Zukowski

*Wob-L-Rite*, 1979
Acrylic on fabric
48 x 107 inches
Marieluise Hessel Collection,
Hessel Museum of Art, Center for
Curatorial Studies, Bard College,
Annandale-on-Hudson, New York

*Ad Jile*, 1980
Gouache on paper collage
37½ x 57 inches
Courtesy of the artist

*Ashe Bole*, 1980
Gouache and postcards on paper
22¼ x 26¼ inches
Courtesy of the artist

*Battery Cell*, 1980
Acrylic on paper
18¼ x 16 inches
Collection of Dr. and Mrs. J. Harley Quint

*Bronco*, 1980
Gouache on paper
15 x 21¼ inches
Courtesy of the artist

*Dil*, 1980
Gouache and postcards on paper
22¼ x 26¼ inches
Collection of Nina MacConnel and
Tom Chino

*Enjoy Five*, 1980
Gouache on paper collage
48 x 87 inches
Courtesy of the artist

*Goalie*, 1980
Gouache on paper
13 x 19½ inches
Collection of Erika and Fred Torri

*Namah*, 1980
Dyed and printed silk
93 x 133 inches
Mingei International Museum,
Gift of Laurie and Brent Woods

*Orange Sliding*, 1980
Silk-screened paper and Plexiglas box
29 x 25 x 5 inches
Courtesy of the artist

*Pass Eight*, 1980
Gouache on paper collage
48 x 87 inches
Courtesy of the artist

*Shoesettes*, 1980
Acrylic on fabric
96 x 108 inches
Collection of Nina MacConnel and
Tom Chino

*Touristic*, 1980
Acrylic on fabric
93 x 123 inches
Courtesy of the artist

*Bomb*, 1981
Painted cardboard
33 ½ x 32 ¼ x 2 ¾ inches
Courtesy of the artist

*Missile*, 1981
Painted cardboard
69 x 37 ½ x 2 ½ inches
Courtesy of the artist

*Nutritious*, 1981
Acrylic on fabric
93 x 130 inches
Courtesy of the artist

*Satellite*, 1981
Painted cardboard
37 ½ x 32 x 2 ½ inches
Courtesy of the artist

*The Theatre*, 1981
Gouache on paper
18 x 68 inches
Museum of Contemporary Art
San Diego, Gift of David and
Patsy Marino

*The Charles Taylor Chair*, 1984
Painted furniture
33 x 35 ½ x 33 inches
Courtesy of the artist

*Green Striped Chair*, 1984
Painted furniture
29 ½ x 21 ½ inches
Courtesy of the artist

*Nautical*, 1984
Gouache on paper
30 x 37 ½ inches
Courtesy of the artist

*Afro Lounger*, 1985-90
Painted furniture
29 x 28 x 60 inches
Courtesy of the artist

*Door Knocker*, 1985
Acrylic on fabric
69 x 79 inches
Courtesy of the artist

*Hooked Rug Sampler*, 1985
Hooked rug samplers
60 x 78 inches
Courtesy of the artist

*Horsey Set*, 1985
Acrylic on fabric
94 x 108 ¾ inches
Museum of Contemporary Art
San Diego, Gift of Laurie and
Brent Woods

*Hula Girl*, 1986
Acrylic on canvas with painted frame
32 x 26 inches
Collection of John and Thomas
Solomon

*Indian Stars*, 1986
Acrylic and postcards on canvas
24 x 28 inches
Courtesy of the artist

*Mario's #77*, 1986
Acrylic and postcards on canvas
18 x 21 ¾ inches
Courtesy of the artist

*Roman Landscape*, 1986
Acrylic on canvas with found frames
56 x 73 x 5 inches
Courtesy of the artist

*Tulip Chair*, 1986
Painted furniture
30 x 30 x 30 inches
Courtesy of the artist

*Bongo*, 1987
Acrylic and flocking on canvas
48 x 91 ½ inches
Courtesy of the artist

*Greetings from Tijuana (Iran)*, 1987
Acrylic and postcards on canvas
18 ½ x 22 ½ inches
Courtesy of the artist

*Large Hooked Rug*, 1987
Hooked rug samplers
119 x 192 inches
Courtesy of the artist

*Pilgrim*, 1987
Acrylic and postcards on canvas
20 ½ x 26 ¼ inches
Courtesy of the artist

*Souvenir #6*, 1987
Acrylic, postcards, and objects
on canvas
19 ½ x 24 inches
Courtesy of the artist

*Sri Ventakeshwara*, 1987
Acrylic and postcards on canvas,
framed
18 ½ x 22 ½ inches
Courtesy of the artist

*Cara Dos Mil*, 1988
Acrylic and flocking on canvas
90 x 90 ½ inches
Courtesy of the artist

*Gondolier*, 1988
Acrylic on flocked paper and cardboard
25 ½ x 29 inches
Courtesy of the artist

*Máscara Cien Caras*, 1988
Acrylic and flocking on canvas
90 x 138 inches
Collection of Ellen and Jimmy Isenson

*Sketch for Black Ground Velvet
Painting*, 1988
Gouache on paper
8 ½ x 11 ½ inches
Courtesy of the artist

*Untitled*, 1988
Acrylic and flocking on paper
23 x 29 ½ inches
Courtesy of the artist

*Zinga*, 1988
Acrylic and flocking on canvas
39 ½ x 36 inches
Private collection

*African Photo Wall*, 1989-90
Photographs in frames painted with
mud and acrylic
Dimensions variable
Courtesy of the artist

*Fetish Lamp (Bound Figure)*, 1990
Mixed objects
96 x 20 x 20 inches
Courtesy of the artist

*Fetish Lamp (Cooking Pot)*, 1990
Mixed objects
70 ½ x 15 ½ x 11 ½ inches
Courtesy of the artist

*Meilleurs Voeux*, 1990
Photographs, wood, and cardboard
87 x 198 inches
Courtesy of the artist

*Baule*, 1991
Acrylic and flocking on canvas
28 ½ x 32 inches
Collection of Elvi Olesen and
Richard Singer

*La Linea Internacional*, 1991
Acrylic and photocopies on canvas
89 ½ x 124 ½ inches
Courtesy of the artist

*Sonaye*, 1991
Acrylic and flocking on canvas
30 ½ x 36 inches
Collection of Susanna and
Michael Flaster

*Snapshots from India*, 1992
Photographs in painted frames
Dimensions variable
Courtesy of the artist

*Untitled*, 1992
Acrylic and flocking on paper
24 x 30 inches
Courtesy of the artist

*Wishing You Best of Luck*, 1992
Acrylic and photocopies on canvas
69 x 89 inches
Courtesy of the artist

*Untitled*, 1993
Glass clowns on painted cardboard
console
Dimensions variable
Courtesy of the artist

*Beach Trash Clowns: Big Foot, Coffee,
Semifore, Weber, Gott, Tipsy, Wash,
Testing, Timotei, Brillo, Professor,
Green Bottle, Emmett, Ghost*, 1994
Assembled found objects
Dimensions variable
Courtesy of the artist

*Flota*, 1994
Assembled found objects, metal stand, and acrylic on canvas
78 x 48 inches
Courtesy of the artist

*Magno*, 1994
Plastic beach trash clown, metal stand, and acrylic on canvas
78 x 48 inches
Courtesy of the artist

*Earth Day Sexy*, 1995
Acrylic, photocopies, and objects on canvas
96 x 115 inches
Courtesy of the artist

*Greek Tweed*, 1995
Painted furniture
35 x 28 x 21 inches
Courtesy of the artist

*Al Dafar*, 2002
C-prints with painted frame
67¾ x 58¾ inches
Courtesy of the artist

*Al Mashad*, 2002
C-prints with painted frame
57¼ x 65½ inches
Courtesy of the artist

*All that is in the moment—sun in the morning; falling water; happiness; the woods; nature—all is momentary. It is all god's holdings, and will be taken back.*, 2002
C-prints with painted frame
48 x 93¼ inches
Courtesy of the artist

*Be serious about the present. Why regret what takes place in the middle of the day in the middle of the night? What can benefit you to think on this?*, 2002
C-prints with painted frame
63½ x 75 inches
Courtesy of the artist

*Haban*, 2002
C-prints with painted frame
58½ x 58½ inches
Courtesy of the artist

*Jiblah*, 2002
C-prints with painted frame
70 x 86 inches
Courtesy of the artist

*Of the nature of human beings there are also four truths: fame for accomplishments; fame for title/name; fame for money/riches; fame for class/position. The past flicks in front of the eyes. It is empty. It is hard to see clearly the pattern in the weave. The physical body contains a gift: ability and skill.*, 2002
C-prints with painted frame
64½ x 76 inches
Courtesy of the artist

*4 Pattern Dub (#1)*, 2004
Acrylic on fabric
102 x 108 inches
Courtesy of the artist

*4 Pattern Dub (#4)*, 2004
Acrylic on fabric
102 x 108 inches
Courtesy of the artist

*4 Pattern Dub (#5)*, 2004
Acrylic on fabric
102 x 108 inches
Courtesy of the artist

*Untitled*, 2004
Latex acrylic on canvas
25 x 25 inches
Collection of Charles Reilly and Mary Beebe

*Clown*, 2005
Cast aluminum painted with enamel
23 x 9 x 5¼ inches
Museum of Contemporary Art San Diego, Museum Purchase, Louise R. and Robert S. Harper Fund

*Woman with Mirror, #1*, 2007
Latex acrylic on canvas
48 x 48 inches
Courtesy of Glenn Schaeffer

*Woman with Mirror, #4*, 2007
Latex acrylic on canvas
48 x 48 inches
Courtesy of the artist and Rosamund Felsen Gallery, Santa Monica

*Woman with Mirror, #6*, 2007
Latex acrylic on canvas
48 x 48 inches
Courtesy of the artist and Rosamund Felsen Gallery, Santa Monica

*Woman with Mirror, #7*, 2007
Latex acrylic on canvas
48 x 48 inches
Collection of Charles Reilly and Mary Beebe

*Woman with Mirror, #8*, 2007
Latex acrylic on canvas
48 x 48 inches
Courtesy of the artist and Rosamund Felsen Gallery, Santa Monica

*Woman with Mirror, #9*, 2007
Latex acrylic on canvas
48 x 48 inches
Collection of Leon and Sofia Kassel

*Woman with Mirror, #10*, 2007
Latex acrylic on canvas
48 x 48 inches
Courtesy of the artist

*Woman with Mirror, #12*, 2007
Latex acrylic on canvas
48 x 48 inches
Courtesy of the artist and Rosamund Felsen Gallery, Santa Monica

*Woman with Mirror, #13*, 2007
Latex acrylic on canvas
48 x 48 inches
Courtesy of Glenn Schaeffer

*Woman with Mirror, #14*, 2007
Latex acrylic on canvas
48 x 48 inches
Courtesy of the artist and Rosamund Felsen Gallery, Santa Monica

*Woman with Mirror, #22*, 2007
Latex acrylic on canvas
48 x 48 inches
Collection of Renée Comeau and Terry Gulden

*Woman with Mirror, #26*, 2007
Latex acrylic on canvas
48 x 48 inches
Courtesy of the artist

*Woman with Mirror, #27*, 2007
Latex acrylic on canvas
48 x 48 inches
Courtesy of the artist

*Sled Lounger*, 2009
Painted furniture
34 x 31 x 66 inches
Courtesy of the artist

*E123*, 2010
Enamel on wood
Triptych: 46 x 46 inches each
Museum of Contemporary Art San Diego, Museum Purchase, International and Contemporary Collectors Funds

*E4*, 2010
Enamel on wood
46 x 46 inches
Private collection

*Intermission*, 2010
Enamel on panel
Diptych: 11 x 11 feet each
Courtesy of the artist

Pier Paolo Pasolini
*Le Mura di Sana'a*, 1970
Film transferred to video
20 minutes
Courtesy of Kim MacConnel

Opposite: Installation view of the exhibition *Bull Story: An Installation by Jean Lowe and Kim MacConnel*, October 30, 1993 through January 6, 1994, Museum of Contemporary Art, San Diego

Page 90: Installation view, *Collection Applied Design: Kim MacConnel*, 1976, La Jolla Museum of Contemporary Art

Page 91: Richard Armstrong (left) and Kim MacConnel (right), circa 1976. Courtesy of John and Thomas Solomon

Selected Exhibition History and Bibliography

## KIM MACCONNEL

Born Oklahoma City, Oklahoma, 1946
BA (1969) and MFA (1972),
University of California, San Diego

### SELECTED SOLO EXHIBITIONS

**2010**
*Collection Applied Design: A Kim MacConnel Retrospective*, Museum of Contemporary Art San Diego

**2007**
*Woman with Mirror*, Rosamund Felsen Gallery, Santa Monica, California; Quint Contemporary Art, La Jolla, California

**2005**
*Rate of Exchange*, Rosamund Felsen Gallery, Santa Monica, California

**2004**
*4 Pattern Dub*, Rosamund Felsen Gallery, Santa Monica, California

*Kim MacConnel: Pattern and Decoration*, Marion Koogler McNay Art Museum, San Antonio, Texas

**2003**
*Parrot Talk: A Retrospective of Works by Kim MacConnel*, Santa Monica Museum of Art, Santa Monica, California

**2002**
*Arabia Felix and New China: Photographs from Yemen and China*, Rosamund Felsen Gallery, Santa Monica, California

**2001**
*Homage to the Tung Feng: Photographs from China*, Holly Solomon Gallery, New York

**2000**
*Selections from The Beach Collection*, 1990–present, Museum of Contemporary Art San Diego, La Jolla, California

**1998**
*Postcards from India*, Quint Contemporary Art, La Jolla, California

*World Cultures*, Holly Solomon Gallery, New York

**1997**
*Fifty Views of Fuji*, Holly Solomon Gallery, New York

**1996**
*Postcards from India*, Holly Solomon Gallery, New York

**1995**
*Bull Story* (with Jean Lowe), Holly Solomon Gallery, New York

**1994**
*Age of Plastic*, Holly Solomon Gallery, New York; Thomas Solomon's Garage, Los Angeles

*Escalera de los Ancianos/Stairway of the Ancients*, Casa de la Cultura, Tijuana

**1991**
*Hotel Beauregarde*, Holly Solomon Gallery, New York

**1990**
*Decoc Terrae Africano*, Aspen Art Museum, Aspen, Colorado

**1989**
*Furniture Issola*, Cappellini International Arts, Milan Furniture Design Fair

**1988**
*Souvenir del Arte*, Holly Solomon Gallery, New York

**1986**
*Western Painting*, Holly Solomon Gallery, New York; James Corcoran Gallery, Los Angeles

**1982**
*Luftgeschaften*, Holly Solomon Gallery, New York; James Corcoran Gallery, Los Angeles

**1981**
*Commerce, Agriculture, Industry: Leading the Way*, The Mayor Gallery, London

*Thunderbomb*, Galerie Rudolf Zwirner, Cologne

**1979**
*Flies*, Holly Solomon Gallery, New York

*Fundamental Series*, Dart Gallery, Chicago

**1978**
*China Trade Leisure Traffic*, Galerie Bruno Bischofberger, Zurich

*Third World Series*, MATRIX Gallery, University Art Museum, University of California, Berkeley

**1976**
*Collection Applied Design: Kim MacConnel*, La Jolla Museum of Contemporary Art, La Jolla, California

**1975**
*Kim MacConnel: Collection Applied Design*, Holly Solomon Gallery, New York

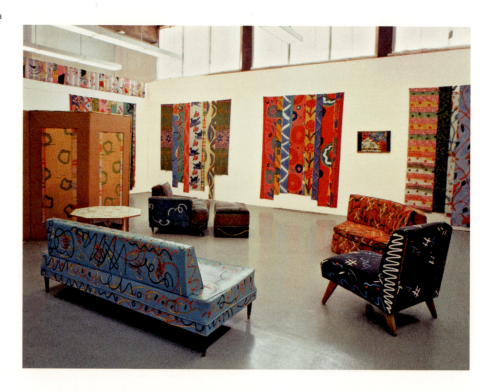

## SELECTED GROUP EXHIBITIONS

2010
*Pop Goes the World*, Pavel Zoubok Gallery, New York

*That Is Then, This Is Now*, CUE Art Foundation, New York

2007-08
*Pattern and Decoration: An Ideal Vision in American Art, 1975-1985*, Hudson River Museum, Yonkers, New York

2003
*LAPD: Pattern and Decoration in Southern California*, Rosamund Felsen Gallery, Santa Monica, California

*NYPD: Pattern and Decoration in New York*, Shoshana Wayne Gallery, Santa Monica, California

2002
*Furniture*, Carnegie Museum of Art, Pittsburgh

*Too Much Joy*, Center for Curatorial Studies at Bard College, Annandale-on-Hudson, New York

1999
*The American Century: Art and Culture—Part II, 1950-2000*, Whitney Museum of American Art, New York

*Comfort Zone: Furniture by Artists*, Whitney Paine Webber Art Gallery, New York

1994
*The Artist's Camera*, American Foundation for AIDS Research (amFAR), Tokyo; Thread Waxing Space, New York

*InSITE '94*, Installation Gallery, San Diego and Tijuana

1993-94
*Bull Story: An Installation by Jean Lowe and Kim MacConnel*, Museum of Contemporary Art San Diego

1992
*FIAC*, Grand Palais, Paris

*InSITE '92*, Tijuana

*The Politics of Cloth: Selections from the Fabric Workshop*, Philadelphia; DeCordova Museum and Sculpture Park, Lincoln, Massachusetts

1991
*Siteseeing: Travel and Tourism in Contemporary Art*, Whitney Museum of American Art, Federal Reserve Plaza, New York

1990
*Concept—Décoratif: Anti-Formalist Art of the 70s*, Nahan Contemporary, New York

1988
*Cultural Camouflage: Andy Warhol, Nam June Paik, Kim MacConnel*, Holly Solomon Gallery, New York

1986
*After Matisse*, Independent Curators Incorporated, Queens Museum, Flushing, New York; Chrysler Museum, Norfolk, Virginia; Portland Museum of Art, Portland, Oregon; Bass Museum of Art, Miami, Florida; The Phillips Collection, Washington, D.C.; Dayton Art Institute, Dayton, Ohio; Worcester Art Museum, Worcester, Massachusetts

*An American Renaissance: Painting and Sculpture Since 1940*, Museum of Art Fort Lauderdale, Fort Lauderdale, Florida

*Amerikanskt 80-Tal*, Neue Galerie—Sammlung Ludwig, Aachen, Germany

1985
*Biennial*, Whitney Museum of American Art, New York

1984
*41st Venice Biennale*, Venice

*American Art Since 1970*, Whitney Museum of American Art, New York

*An International Survey of Recent Paintings and Sculpture*, Museum of Modern Art, New York

*Scene New York*, Art Cologne International

1983
*Back to the USA*, Kunstverein Lucerne, Lucerne, Switzerland; Rheinische Landesmuseum, Bonn; Kunstverein, Stuttgart

*A Contemporary Collection on Loan from the Rothschild Bank AG, Zurich*, La Jolla Museum of Contemporary Art, La Jolla, California

*Minimalism to Expressionism*, Whitney Museum of American Art, New York

1982
*New York Now*, Kestner Gesellschaft, Hannover, West Germany; Cantonal des Beaux-Arts, Lausanne, Switzerland; Kunstverein Rheinlande Westfalen Dusseldorf, West Germany

1981
*Biennial*, Whitney Museum of American Art, New York

1980
*La Nouvelle Tendance de la Peinture Américaine*, Galerie Daniel Templon, Paris

*The Morton G. Neumann Family Collection*, National Gallery of Art, Washington, D.C.; Art Institute of Chicago

1979
*Biennial*, Whitney Museum of American Art, New York

*Directions*, Hirshhorn Museum and Sculpture Garden, Washington, D.C.

1978
*Arabesque*, Contemporary Arts Center, Cincinnati, Ohio

*Southern California Styles of the Sixties and Seventies*, La Jolla Museum of Contemporary Art, La Jolla, California

1977
*Biennial*, Whitney Museum of American Art, New York

1975
*Biennial*, Whitney Museum of American Art, New York

## SELECTED BIBLIOGRAPHY

2007
Pagel, David. "Reconciling Picasso, Matisse." *Los Angeles Times*, September 28, 2007, E18-19.

2006
Lewis, Joe. "Kim MacConnel at Rosamund Felsen." *Art in America* 94, no. 2 (May 2006): 196.

2004
Pagel, David. "MacConnel Unbound." *Art in America* 92, no. 2 (February 2004): 70-73.

Paul, Donna. "Rock the Casbah." *Interior Design* (March 2004): 266-71.

2003
Duncan, Michael, and Lisa Melandri, eds. *Parrot Talk: A Retrospective of Works by Kim MacConnel*. Santa Monica, Calif.: Santa Monica Museum of Art, 2003.

Frankel, David. "The Rite Stuff." *Artforum International* 41, no. 5 (January 2003): 116-17.

Knight, Christopher. "Finding Patterns in the Past." *Los Angeles Times*, September 14, 2003, E53.

Miles, Christopher. "Kim MacConnel." *Artforum* 42, no. 3 (November 2003): 195-96.

Ollman, Leah. "Seeing the Pattern." *Los Angeles Times*, September 21, 2003, E46.

2002
Stroud, Marion Boulton. *New Material as New Media: The Fabric Workshop and Museum*. Edited by Kelly Mitchell. Cambridge, Mass.: MIT Press, 2002. Pages 12, 14, 16, 310, 314.

1999
Landi, Ann. "Kim MacConnel at Holly Solomon." *ARTNews* 98, no. 4 (April 1999): 117-18.

Perl, Jed. "On Art: Intoxicating Heresies." *New Republic*, November 11, 1999.

Phillips, Lisa. *The American Century: Art and Culture, 1950-2000*. New York: Whitney Museum of American Art, 1999. Pages 236-37.

1998
Arnason, H. H., and Marla F. Prather. *History of Modern Art*. 4th ed. New York: Harry N. Abrams, 1998. Page 671.

Johnson, Ken. "Kim MacConnel." *New York Times*, December 18, 1998, E40.

Levin, Kim. "Kim MacConnel." *Village Voice*, Voice Choices supplement, December 1, 1998, 97.

Louie, Elaine. "Scaling Down the Space, But Not the Fantasy." *New York Times*, July 23, 1998, F1, F10.

Morgan, Robert C. *The End of the Art World*. New York: Allworth Press and School of Visual Arts, 1998. Pages 72-73.

———. "Kim MacConnel: World Cultures." *Review*, December 1, 1998, 22, 23.

Moure, Nancy Dustin Wall. *California Art: 450 Years of Painting and Other Media*. Edited by Jeanne D'Andrea, Sue Henger, and Helen Abbott. Los Angeles: Dustin Publications, 1998. Pages 491-92, 547.

Radcliff, Carter. "Politics of Ornamentation." *Art in America* 86, no. 4 (April 1998): 109.

1997
Drohojowska-Philp, Hunter. "Keeping His Eye on the Big Picture." *Los Angeles Times*, September 7, 1997, Calendar, 78, 79.

Koplos, Janet. "Kim MacConnel at Holly Solomon." *Art in America* 85, no. 12 (December 1997): 93.

Vilades, Pilar. "International Style." *New York Times Magazine*, April 20, 1997, pp. 60-62.

1996
"Alighiero e Boetti and Kim MacConnel." *New Yorker*, December 2, 1996, 24.

Sandler, Irving. *Art of the Postmodern Era*. New York: HarperCollins, 1996. Pages 145, 155-57, 164, 194, 216.

Yablonski, Linda. "Jean Lowe and Kim MacConnel." *Artforum* 34, no. 5 (January 1996): 84, 85.

1995
Cotter, Holland. "Kim MacConnel and Jean Lowe: Bullstory." *New York Times*, August 25, 1995, C15.

Duncan, Michael. "Kim MacConnel at Thomas Solomon's Garage and Quint." *Art in America* 83, no. 3 (March 1995): 110.

Levin, Kim. "The Short List." *Village Voice*, Voice Choices supplement, August 1, 1995, 2.

1994
Broude, Norma, and Mary D. Garrard. *The Power of Feminist Art*. New York: Harry N. Abrams, 1994. Pages 129, 210-11, 212-14, 216, 219.

Levin, Kim. "Art Galleries: Recommended Pick." *Village Voice*, Voice Choices supplement, December 6, 1994, 8.

McKenna, Kristine. "Everybody Loves a Clown." *Los Angeles Times*, September 11, 1994, Calendar, 67, 95, 96.

Pagel, David. "Kim MacConnel." *Art Issues*, no. 35 (November/December 1994): 43.

Sperone, Gian Enzo. *The Metophora Trovata*. Rome: Galeria Sperone, 1994. Pages 111-12.

1993
Smith, Roberta. "A Remembrance of Whitney Biennials Past." *New York Times*, February 28, 1993, H31.

1992
Brock, Hovey. "Kim MacConnel at Holly Solomon." *ARTnews* 91, no. 1 (January 1992): 125.

Faust, Gretchen. "Kim MacConnel." *Arts Magazine* 66, no. 5 (January 1992): 87.

Hunter, Sam, and John Jacobus. *Modern Art*. 3rd ed. New York: Harry N. Abrams, Inc., 1992. Pages 382, 383.

Levin, Kim. "Figurations and Configurations: The Rematerialization of Painting in the Seventies." In *American Figurations: Works from the Lilja Collection*. Oslo: Henie Onstad Art Centre and Edition Bløndal, 1992. Pages 12, 16, 17, 62-67.

1991
McEvilley, Thomas. "Kim MacConnel: The Irony of the Decorative." In *Kim MacConnel: Hotel Beauregarde*. New York: Holly Solomon Gallery, 1991.

Slesin, Suzanne. "Ancestor Artifacts that Glow." *New York Times*, October 24, 1991, C3.

Stroud, Marion Boulton. *An Industrious Art: Innovation in Pattern and Print at the Fabric Workshop*. New York: W. W. Norton and Co., 1991. Jacket cover, pages 14, 42, 191, 199.

1990
Silver, Kenneth E. "Kim MacConnel's New African State." In *Kim MacConnel: Decoc Terrae Africano*. Aspen, Colo.: Aspen Art Museum, 1990.

1989
Reed, Christopher. "Off the Wall and Onto the Couch! Sofa Art and the Avant-Garde Analyzed." *American Art*, no. 1 (Winter 1989): 33-43.

Slesin, Suzanne. "At Milan Fair There's Vitality if Not Practicality on Display." *New York Times*, September 28, 1989, B1, B8.

1988
Levin, Kim. "Choices: American Baroque." *Village Voice*, December 27, 1988, 50.

Russell, John. "Cultural Camouflage." *New York Times*, April 1, 1988.

Smith, Roberta. "Into Kim MacConnel's Giant Fabric Showroom." *New York Times*, June 24, 1988, C24.

Solomon, Holly, and Alexandra Anderson. *Living with Art*. New York: Rizzoli, 1988. Pages 39, 40, 47, 48, 62, 76, 79, 131-33, 203-06, 208, 209.

1986
Arnason, H. H. *The History of Modern Art*. 3rd ed. New York: Henry N. Abrams, Inc., 1986. Pages 616-18, 988, plate 280.

Solomon, Holly, and Christopher Knight. *Kim MacConnel: New Paintings on Stretched Canvas.* New York: Holly Solomon Gallery, 1986.

Wilson, William. "Installation of Kim MacConnel at James Corcoran Gallery." *Los Angeles Times*, February 28, 1986.

1985
Hunter, Sam. *Painting and Sculpture Since 1940: An American Renaissance.* New York: Abbeville Press, 1985. Pages 204-06, plate 111.

Plagens, Peter. "Nine Biennial Notes." *Art in America* 73, no. 7 (July 1985): 115-18.

Russell, John. "Art: Whitney Presents Its Biennial Exhibition." *New York Times*, March 22, 1985.

1984
Brenson, Michael. "The Decorative Tradition." *New York Times*, April 20, 1984, C3.

———. "A Living Artists Show at the Modern Museum." *New York Times*, April 21, 1984.

———. "Kim MacConnel and Melissa Miller." *New York Times*, May 11, 1984, C25.

Levin, Kim. "Art: Kim MacConnel." *Village Voice*, May 15, 1984, 76.

Russell, John. "Furniture Reveals the Artist's Touch." *New York Times*, July 5, 1984.

1983
Blau, Douglas. "Kim MacConnel and David Salle." *Arts Magazine* 57, no. 3 (January 1983): 62-63.

Gibson, Ann. "Painting Outside the Paradigm: Indian Space." *Arts Magazine* 57, no. 4 (February 1983): 98-104.

Honnef, Klaus. "New York aktuelle." *Kunstforum International* 61 (May 1983): 38, 128-29.

Perrone, Jeff. "Unfinished Business." *Images and Issues* 3 (January-February 1983): 38-41.

1982
Becker, Robert. "Art: Pattern Painting in Encinitas." *Interview* 12 (June 1982): 52-54.

———. "Kim MacConnel." *Flash Art* 16, no. 107 (May 1982): 50-51.

Madoff, Steven Henry. "Kim MacConnel at Holly Solomon." *Art in America* 70, no. 6 (Summer 1982): 143-44.

Russell, John. "Art: The Deft Hand of Kim MacConnel." *New York Times*, March 12, 1982, C20.

1981
Armstrong, Richard. "Heute." *Artforum International* 20, no. 1 (September 1981): 83.

———. "Westkunst: Kim MacConnel." *Flash Art*, no. 103 (Summer 1981): 29.

Hunter, Sam. "Post-Modernist Painting." *Portfolio* 3 (January-February 1981): 46-53.

Rickey, Carrie. "All Roads Lead to the Venice Biennial." *Village Voice*, June 9, 1981, 71.

———. "Curatorial Conceptions: The Whitney's Latest Sampler." *Artforum* 19, no. 8 (April 1981): 52-57.

Slesin, Suzanne. "Blurring the Boundaries between Art and Furniture." *New York Times*, February 12, 1981, C12.

Smith, Roberta. "Biennial Blues." *Art in America* 69, no. 4 (April 1981): 92-101.

1980
Alinovi, Francesca. "Redecorated Furniture." *Domus*, no. 611 (November 1980): 38-39.

Delahoyd, Mary. "Action and Abstraction." *Artforum* 19, no. 3 (November 1980): 62-63.

Gibson, Michael. "Around the Galleries." *International Herald Tribune*, January 19, 1980, 7.

MacConnel, Kim. *Paris Review*, no. 78 (Summer 1980). Cover illustration.

———. "Projects." *Artforum* 18, no. 6 (February 1980): 55-58.

Michel, Jacques. "Connaissez-vous le 'Pattern'?" *Le Monde*, September 17, 1980.

Perrone, Jeff. "Fore, Four, For, Etc." *Arts Magazine* 54, no. 7 (March 1980): 84-89.

Pohlen, Annelie. "Die Neuen Wilden: Les Nouveaux Fauve." *Flash Art*, no. 96-97 (March-April 1980): 55.

Russell, John. "70's Art in Public Places—From Anchorage to Atlanta." *New York Times*, July 6, 1980.

Tomkins, Calvin. "Matisse's Armchair." *New Yorker*, February 25, 1980, 108.

1979
Ashbery, John. "Decoration Days." *New York Magazine*, July 2, 1979, 51.

Boudaille, Georges. "Pattern Painting." *Connaissance des Arts*, no. 331 (September 1979): 54.

Hughes, Robert. "Roundup at the Whitney Corral." *Time*, February 26, 1979, p. 72.

Perreault, John. "The New Decorativeness." *Portfolio* 1 (June-July 1979): 46.

Rickey, Carrie. "Art of the Whole Cloth." *Art in America* 67, no. 7 (November 1979): 192.

Saunders, Wade. "Art, Inc.: The Whitney's 1979 Biennial." *Art in America* 67, no. 3 (May-June 1979): 96.

1978
Auping, Michael. *Kim MacConnel.* Berkeley, Calif.: University Art Museum, University of California, Berkeley, 1978.

Meyer, Ruth K. *Arabesque: Joyce Kozloff, Robert Kushner, Kim MacConnel, Rodney Ripps, Barbara Schwartz, Ned Smyth.* Cincinnati: Contemporary Arts Center, 1978.

Rickey, Carrie. "Pattern Painting." *Arts Magazine* 52, no. 5 (January 1978): 17.

1977
MacConnel, Kim. "Crepe du Chine." *LAICA Journal*, no. 14 (October-November 1977): 36-39.

———. "What You See Is What You Get." In *Art-Rite* #17. New York: Art-Rite Publishing Company, 1977.

Russell, John. "Robert Benson, Kim MacConnel." *New York Times*, June 3, 1977.

Shirey, David L. "Diverse and Lively." *New York Times*, February 27, 1977, C/W 13.

1976
Armstrong, Richard. *Collection Applied Design: Kim MacConnel.* La Jolla, Calif.: La Jolla Museum of Contemporary Art, 1976.

Auping, Michael. "Kim MacConnel: Questioning Taste." *Artweek* 7, no. 14 (April 3, 1976): 4.

Goldin, Amy. "Review." *Art in America* 64, no. 3 (May-June 1976): 109-10.

Perrone, Jeff. "Approaching the Decorative." *Artforum* 15, no. 4 (December 1976): 26-30.

1975
Goldin, Amy. "The New Whitney Biennial: Pattern Emerging?" *Art in America* 63, no. 3 (May-June 1975): 72-73.

"Review." *Village Voice*, December 8, 1975, centerfold.

# Board of Trustees

FISCAL YEAR 2011
Barbara Arledge
Linnea Arrington
Melissa Garfield Bartell
Dr. Mary F. Berglund
Carolin Botzenhardt
Charles Brandes
Wendyce H. Brody
Nancy Browar
Christopher Calkins
Dr. Charles G. Cochrane
Valerie Cooper
David C. Copley
Dr. Peter C. Farrell
Pauline Foster
Murray A. Gribin
David Guss
Margaret A. Jackson
Dr. Paul Jacobs
Leon Kassel
Vekeno Kennedy
Gail Knox
Sami Ladeki
Mary Keough Lyman
Holly McGrath
Robin Parsky
Maryanne C. Pfister
Dr. Carol Randolph
Colette Carson Royston
Faye H. Russell
Nora D. Sargent
Matthew C. Strauss
Sheryl White
Brent V. Woods

HONORARY TRUSTEES
Sue K. Edwards

# Staff

Hugh M. Davies, PhD,
The David C. Copley Director and CEO

### DIRECTOR'S OFFICE
Lilli-Mari Andresen, Executive Assistant to the Director
Megan Nesbit, Administrative Assistant,
　Director's Office

### BUSINESS OFFICE
Charles E. Castle, Deputy Director and CFO
Trulette M. Clayes, CPA, Controller
Catherine Lee, Human Resources Manager
Jen Riley, Accountant
Tiffani Mai, Accounting Clerk

### CURATORIAL
Kathryn Kanjo, Chief Curator
Robin Clark, PhD, Curator
Lucía Sanromán, Associate Curator
Gabrielle Wyrick, Education Curator
Neil Kendricks, Film Curator*
Jenna Siman, Curatorial Manager
Therese James, Associate Registrar
Cameron Yahr, Registrarial Assistant
Elizabeth Yang-Hellewell, Education Programs
　Coordinator
Ame Parsley, Chief Preparator
Jeremy Woodall, Assistant Preparator
Thomas Demello, Assistant Preparator
Ali Hennessey, Research Assistant*

### ADVANCEMENT
Jeanna Yoo, Chief Advancement Officer
Cynthia Tuomi, Stewardship Manager
Heather Cook, Advancement Associate
Julia Altieri, Membership Coordinator
Lesley Emery, Events Coordinator
Diana Mason, Advancement Coordinator
Angela Bartholomew, Grants Coordinator
Megan Skidmore, Advancement Assistant

### COMMUNICATIONS
Rebecca Handelsman, Senior Communications and
　Marketing Manager
Claire Caraska, Communications Associate
Mara Daniels, Visitor Services Supervisor
Cindy Kinnard, Lead Visitor Services Representative

### GRAPHIC DESIGN
Ursula Rothfuss, Manager of Graphic Design
Isabelle Heyward, Graphic Designer/
　Production Coordinator*

### HOSPITALITY AND EVENTS
Edie Nehls, Hospitality and Events Manager
Eric Reichman, Hospitality and Events Coordinator
Mike Scheer, Production Coordinator*

### RETAIL SERVICES
Monique Fuentes, Manager of Retail Operations

### FACILITIES
James Patocka, Facilities Manager
Kathlene J. Gusel, IT and Projects Manager
Tauno Hannula, Facilities Technician
Christian Akers, Facilities Technician

### SECURITY SERVICES
Justin Giampaoli, Chief of Security
Javier Martinez, Security Specialist
David Mesa, Security Specialist
George Garcia, Senior Security Services Representative

*denotes part-time

# Image Credits

Frontispiece
Kim MacConnel
Photo: Pablo Mason

p. 7
Studio
Photo: Pablo Mason

p. 10
Kim MacConnel
Photo: Pablo Mason

p. 12
Holly Solomon
Courtesy of John and Thomas Solomon
Photo: John Solomon

p. 13
Holly Solomon
Courtesy of John and Thomas Solomon

p. 15
Gordon Matta-Clark
© The Estate of Gordon Matta-Clark
Courtesy the Estate of Gordon Matta-Clark and David Zwirner, New York

p. 17, top
Valerie Jaudon
Hirshhorn Museum and Sculpture Garden, Smithsonian Institution,
Gift of Joseph H. Hirshhorn, 1977

p. 17, bottom
Robert Kushner
Courtesy of Robert Kushner

p. 21
Chez Es Saada
Reproduced from *Interior Design* (March 2004)
© 2010 by Sandow Media
Photo: Eric Laignel

p. 29, top
Henri Matisse
© 2010 Sucession H. Matisse/Artists Rights Society (ARS), New York

p. 30, top
Robert Morris
Digital image © The Museum of Modern Art/Licensed by SCALA/ Art Resource, NY
© 2010 Robert Morris/Artists Rights Society (ARS), New York

p. 30, bottom
Stuart Davis
Image © The Metropolitan Museum of Art/Art Resource, NY
© Estate of Stuart Davis/Licensed by VAGA, New York, NY

p. 32
Raoul Dufy
© 2010 Artists Rights Society (ARS), New York/ADAGP, Paris

p. 33
Sigmar Polke
© FMGB Guggenheim Bilbao Museoa, 2010
Photo: Erika Barahona-Ede

p. 35, bottom
Robert Rauschenberg
© Estate of Robert Rauschenberg/Licensed by VAGA, New York, NY

p. 36
Joan Miró
© 2010 Successió Miró/Artists Rights Society (ARS), New York/ADAGP, Paris
Photo: David Heald

p. 37, top
Pablo Picasso
Digital image © The Museum of Modern Art/Licensed by SCALA/ Art Resource, NY
© 2010 Estate of Pablo Picasso/Artists Rights Society (ARS), New York

pp. 68–69
Kim MacConnel
Courtesy of the artist and Rosamund Felsen Gallery, Santa Monica
Photos: Roy Porello

pp. 72–81
Installation views
*Collection Applied Design: A Kim MacConnel Retrospective*
Photos: Pablo Mason

p. 85
Mural
Photo: Pablo Mason

p. 91
Kim MacConnel and Richard Armstrong
Courtesy of John and Thomas Solomon

All images are courtesy of the artist unless otherwise noted.

N 6537 .M324 A4 2010
MacConnel, Kim, 1946-
Collection applied design

WITHDRAWN